ScriptureDoodle

A Six-Week Devotional Experience

April Knight

David C Cook

transforming lives together

SCRIPTUREDOODLE
Published by David C Cook
4050 Lee Vance View
Colorado Springs, CO 80918 U.S.A.

David C Cook U.K., Kingsway Communications
Eastbourne, East Sussex BN23 6NT, England

The graphic circle C logo is a registered trademark of David C Cook.

The website addresses recommended throughout this book are offered as a resource
to you. These websites are not intended in any way to be or imply an endorsement
on the part of David C Cook, nor do we vouch for their content.

ISBN 978-0-7814-1469-2

The Author is represented by and this book is published in association with the literary
agency of WordServe Literary Group, Ltd., www.wordserveliterary.com.

The Team: Alice Crider, Cara Iverson, Helen Macdonald, Susan Murdock
Cover Design: Amy Konyndyk and April Knight

Printed in the United States of America
First Edition 2016

1 2 3 4 5 6 7 8 9 10

072816

CONTENTS

INTRODUCTION

I often say that the birth of ScriptureDoodle was a holy deposit from heaven. It began a few years ago as a creative devotional venture for myself. As an artist, it's easy to meet a deadline for a client or create work for someone else, but to just sit and create for the sake of art—and really for the act of worship—doesn't happen frequently. During that season, my work had become driven less by my passion and more by the need to make a living. I felt God calling me to work toward creativity in my everyday life, sharpen my skills as an artist, and also engage in creative worship daily. And that is when he gave me the idea of scripturedoodling: reading a Bible verse and drawing a picture of what it could look like.

The moments of my first scripturedoodle looked like this: I was sitting at my husband's desk after a long day of work and wanted to do something creative with God. I feel it necessary to tell you I was in a crummy mood that day, in a funk, and I wasn't searching for some great idea; I just wanted a moment with the Lord to fix my heart. Have you ever been there? I opened the Bible and randomly turned to this bizarre verse:

> *Daughter Zion is left*
> *like a shelter in a vineyard,*
> *like a hut in a cucumber field,*
> *like a city under siege. (Isaiah 1:8)*

I guess it's not that bizarre as I read it now, but I didn't understand the significance of a hut in a cucumber field. I'm sure the Lord will tell me someday. But as I read the words, I immediately got this visual image in my mind of a cucumber field with a hut in the middle of it. I grabbed a piece of paper and a ballpoint pen and started to doodle it. I wrote the words of the verse and the Bible reference around the picture, and that was it. That was the beginning of ScriptureDoodle. The purpose was not excellence but rather expression of the heart. ScriptureDoodle is not about making a masterpiece; it is about worship.

Social media easily became the avenue for ScriptureDoodle, originally noted as #scripturedoodle. I used it as a sort of accountability for myself. I would try to post a verse daily and an illustration of the verse, and I thought maybe someone would look forward to seeing it. Perhaps it would bless people. As time went on, friends would mention in passing that they were trying ScriptureDoodle for themselves. Through that, God revealed to me that ScriptureDoodle was for anyone, not just for me and not just for the artist. It's for anyone who is a worshipper, for there is freedom in Christ! And just as everyone is free to sing a worship song, everyone has the right to explore visual art in the way of creative worship. Truly the heart of it all is to bring God glory. The purpose of ScriptureDoodle is to look at Scripture in a new way, allow God to reveal his Word to us visually, aid in Scripture memory, and share the truth of Jesus. That's what it has been for me, and I pray it's the same for you.

"Daughter Zion is left like a shelter in a vineyard,

LIKE A HUT

IN A CUCUMBER FIELD

like a City under Siege."

—ISAIAH 1:8—

HOW TO USE THIS BOOK

This book is designed to be your guide for a six-week devotional journey through creative expression with God. There are enough exercises to do one per day for six weeks with a few bonus activities at the end, but feel free to work at your own pace. ScriptureDoodle is also intended to be progressive, so it may be best to move through it in chronological order. However, you might instead choose to jump around to whatever pages inspire you. The goal is to become familiar and very comfortable with scripturedoodling and to deepen your connection to God through his Word. In case you would say, "I'm not an artist," please know there is freedom in the creative space of ScriptureDoodle. There are no rules, and the only way to do it wrong is to not do it at all.

The next few pages will show you what basic materials you'll need to have on hand as well as coloring and lettering tips. You'll get some practice pages for those and then progress into easy doodles and bordering. From there, you'll do some simple activities to stir up your visual imagination. Throughout the book, you'll encounter exercises and prompts designed to help you try new things in the doodle realm. Think of this as creating your own devotional along the way. As you work through the book and approach the finish, there will be less instruction and more freedom to create. Once you finish, you will be a ScriptureDoodle ninja ready with pen and paper whenever the spirit moves.

Each exercise begins with a Bible verse and proceeds to a creative worship activity. As you work through each page, don't be afraid to try a new thing or draw something you've never drawn before. Let it be imperfect. It's not about being the best; it's about opening your heart to God in a new way, for he is worthy of all our worship.

For easy reference, here is how to scripturedoodle (on any size paper or card):

1. Choose a Bible verse—any Bible verse.
2. Pick one key word or phrase in the verse that brings a picture to mind.
3. Begin by drawing that image (or you can do text only).
4. Add elements around that image to fill out your page.
5. Write out the Bible verse somewhere on the page.
6. Create borders and other doodles.
7. Color it if you want.

Recent research shows that doodling helps people stay focused, grasp new concepts, and retain information.[1] It can be used to:

- Focus on things above

- Worship God

- Grasp biblical truths

- Memorize Scripture

- Enhance Bible study and devotional experience

As you work through the pages ahead, feel free to make notes and doodles anywhere you want. Test your colors and practice your lettering. These pages are for you, so please use them. If you come to a page and think, **I'm not sure I can do that**, just give it a try. You have nothing to lose; in fact, you have everything to gain!

Please share your work online so others can follow your **ScriptureDoodle** journey, enjoy seeing your doodles, and be encouraged! Post your favorite pages and exercises on social media tagging @scripturedoodle and using the hashtag #scripturedoodle.

1 Sue Shellenbarger, "The Power of the Doodle: Improve Your Focus and Memory," *Wall Street Journal*, July 29, 2014, http://www.wsj.com/articles/the-power-of-the-doodle-improve-your-focus-and-memory-1406675744.

BASIC MATERIALS AND COLORING TIPS

Basic Materials

You don't need much to get started scripturedoodling. Here's a list of recommended art supplies that can make your ScriptureDoodle experience lovely.

- A sharp pencil or two and a few ballpoint pens (any colors)
- A pencil sharpener
- A large eraser (such as Magic Rub by Prismacolor)
- 12–24 colored pencils (Crayola or Prismacolor are great choices)
- Pastels
- Ruled notebook paper (for lettering practice)
- Blank index cards

Some colored markers, felt-tip pens, and gel pens might bleed through these pages, so wait to use them until you're ready to break out of this book and scripturedoodle on your own. At that point, you might wish to try watercolor pencils or even a brush pen, which is a popular choice for hand lettering.

All these supplies can be found at your local art store.

Coloring Tips

Coloring is a relaxing pastime that has been newly revived among the adult community. You might be quite comfortable with your coloring ability, but here are a few coloring tips that you can practice and also refer to along the way.

THE COLOR WHEEL

There are three primary colors—red, blue, and yellow—from which every color in the world is created. The secondary colors are green, orange, and violet, which are made from the primaries.

God is the master artist, and he's phenomenal at using color to make the most beautiful tones, highlights, and shadows. In this book, you'll most likely be working with colored pencils, which are a great choice, and with a little practice you can use color to make beautiful works of art

yourself. Practice each of the following tips in the margins of the page to get comfortable with your colors.

OVERLAP

You can create dimension in your picture by combining colors that are next to one another on the color wheel. For example, if you're coloring a sun, instead of just using yellow you can also include orange and even a little red too.

VALUE

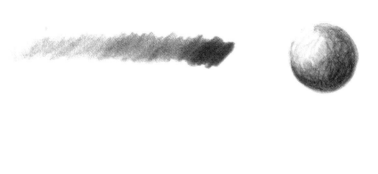

Value is the lightness or darkness of a color. When using colored pencils, value is a useful tool. Press lightly to create a light tone, and firmly to make a darker tone. To achieve a shadow on an object, try overlapping your base tone with some light pressure on a brown or black colored pencil.

COLOR

Use yellow, gold, peach, and orange to show light. Also, consider leaving white space to create the brightest highlight. There will be an absence of color, which will make the highlight pop. When coloring dark sections, use violet and blue to create shadows.

TECHNIQUE

Hold your sharpened colored pencil in the middle and bring it down close to the page so you can use the smooth, flat side of the point. This will help you achieve even tones as you shade.

JUMP-START CREATIVITY

The Lord is the Spirit, and where the Spirit of the Lord is, there is freedom. (2 Corinthians 3:17)

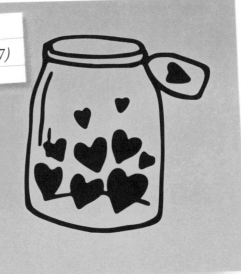

When you think of freedom, perhaps a wild mustang roaming free comes to mind. As you journey through these pages, may you experience freedom to find a new way that makes you feel free. Consider choosing bright colors and giving the horse stripes or spots or even a rainbow mane. As you color, remind yourself that there is freedom in Christ—freedom to take risks and try new things, even outside your place of comfort.

"Where the Spirit of the Lord is

There is Freedom!"

2 Corinthians 3:17

LETTERING TIPS

Handwritten text is a classic characteristic of **Scripture Doodle**. The Word of God is the source of creativity here, so including Scripture in your doodles is possibly the best part of the process.

If hand lettering and pretty writing is not your number one skill, have no fear! Compiled here are some great lettering tips to help you on your way. And remember, practice makes progress. So the more time you spend creating letters and fonts, the better you will get at them.

When you draw letters, take time to think about every part of them. Will you write them in print or cursive? How about writing in all CAPS? Will you include any numbers in your writing? How tall do you wish to make the letters? Think about the length of each side of the letters; will they be symmetrical or not? Will each letter be similar to one another as a printed font would be? All of these are questions to ponder when you wish to take time on your lettering. Practice these tips in the space of the margins by seeing if you can match these letters. Then try creating your own as well.

Aa Bb Cc Dd Ee Ff Gg
Hh Ii Jj Kk Ll Mm Nn
Oo Pp Qq Rr Ss Tt Uu
Vv Ww Xx Yy Zz

Aa Bb Cc Dd Ee Ff Gg Hh
Ii Jj Kk Ll Mm Nn Oo Pp
Qq Rr Ss Tt Uu Vv Ww Xx
Yy Zz

God is good

EASY DOODLES

Let's begin to get our feet wet with 𝒮𝒸𝓇𝒾𝓅𝓉𝓊𝓇ℯ𝒟𝑜𝑜𝒹𝓁ℯ by using this quick exercise that explores doodles you're already comfortable drawing. First, begin with a simple shape. Some suggestions: star, flower, heart, feather, arrow, bird, leaf. Choose one to start with, and then feel free to try the exercise with other shapes. Draw your selected shape however you normally would. Then try to draw four other versions of the same shape so that when you finish, you have five different hearts, flowers, stars, and so on. As you're working through the different versions of your shape, consider such things as size, color, and extra details. For example, if you draw a heart, maybe your second heart has a double outline and perhaps the third heart you draw is more flowy in shape. And for the fourth, think about what design you could use to fill the inside.

Continually ask yourself, **How can I make this shape different from the one before?** The differences don't have to be major; they can be subtle. A slight variation can really set a shape apart from its siblings. When you think of the shape as a whole, see if you can stretch it out to elongate it or squash it down to give it a fatter shape. Incorporating all these elements will help you develop your doodling skills and give you freedom and confidence for the pages ahead.

Five variations of the same shape:

Add subtle differences to set a shape apart:

VISUAL SCRIPTURE

ScriptureDoodle began solely because of the words of life in the Bible, and as a result, the words in Scripture truly guide the creativity of the process. As you start your way through these pages, let each passage be your guide as to how you illustrate a verse.

When you pick a verse to doodle, circle key words in the text that bring visual images to mind. They can be action words or nouns or even descriptive words. Also, you don't always have to choose just one word; you can pick a phrase. Take this verse for example:

> The steadfast love of the Lord never ceases;
> his mercies never come to an end;
> they are new every morning;
> great is your faithfulness. (Lamentations 3:22-23 ESV)

Now ask yourself, **What picture or symbol would represent this word?** Usually there is a clear-cut answer. In this case, if you chose **love**, you could easily draw a heart. Or you could choose **every morning** and draw a more detailed picture of a sunrise, as shown to the right. As the doodler, you get to choose. Regardless, let the words of the Bible verse be your guide.

Sometimes you may get stumped on how you want to illustrate the verse because the key word might not be super visual. In that case, stretch your brain a little more and think, **What is something related to this word that could be a visual representation?** For example, the word **hospitality** comes up in Scripture often, but it might not bring an image instantly to mind. So think of something that could represent the word: perhaps hands serving an apple pie or something you would give to a neighbor. The more time you spend thinking visually about God's Word, the easier it becomes to scripturedoodle.

For this exercise, the key words have already been illustrated for you. So focus on creating beauty in the sunrise representing the beauty of God's fresh mercies each day. Refer back to the coloring tips if needed. Think yellows, pinks, and oranges. Write the text of the verse in a creative way using color, font, and size.

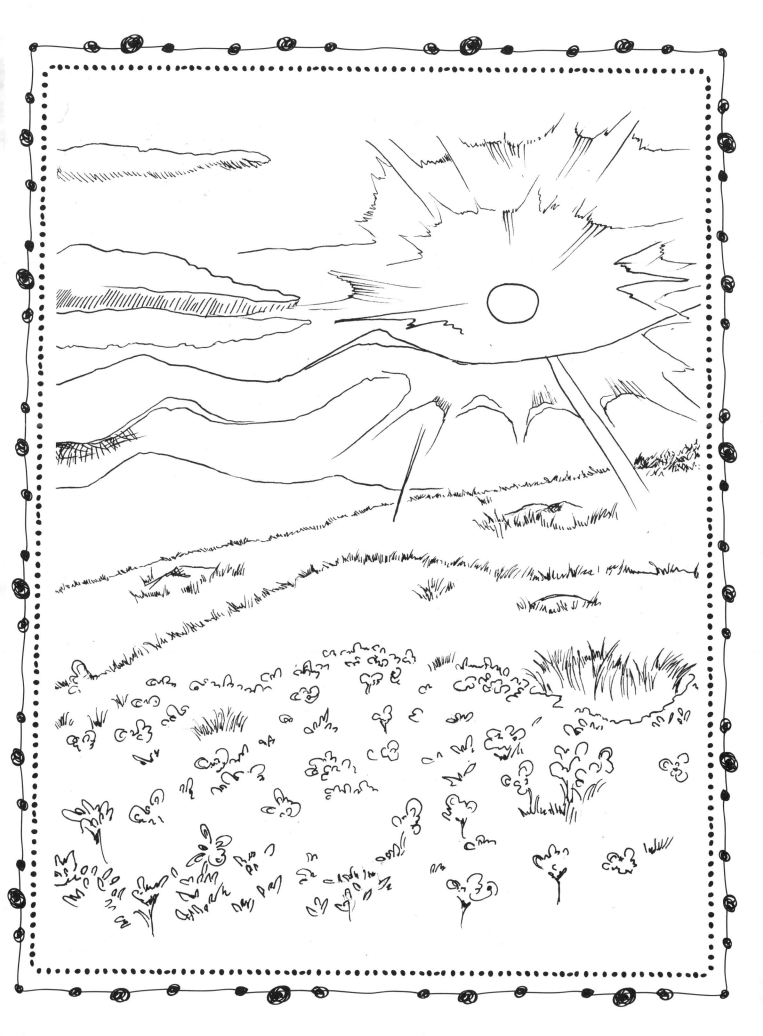

BORDERS

Adding a border is a great way to spice up your scripturedoodle and bring it together. It can be as simple as one solid line, or it can be a detailed variation of shapes and lines. There are unlimited options. For this exercise, start by stretching your creativity and ability to create a border. Use a line and a dot to create your first series of borders on the page to the right. Make five different border styles using only these two shapes. As you create, consider how each border can be different by using repetition and size. Also, change the direction your lines are going and the number of dots you use. Here are a few examples:

Now let's move on to creating more borders using various shapes and objects. You can use some of the shapes you developed on the "Easy Doodles" page. Feel free to use them at random; they don't have to go together. These types of borders are fun and easy to work into your scripturedoodle designs because they don't have one defined theme. Create five more unique borders using any combination of lines and shapes.

Finally, create one border with a cohesive theme. Think of something in nature or in the world that you can create a themed border around. For example, in nature you could choose "plant life" and include leaves, flowers, and branches. Or for "school," you could draw letters, a schoolhouse, a chalkboard, and an apple. There are many possibilities. Choose your theme and then begin your border. As you work, consider the same elements as before: line, shape, repetition, size, color, and so on. All these elements will help you create an awesome border!

SCRIPTURE MEMORY

*I have hidden your word in my heart
that I might not sin against you. (Psalm 119:11)*

Memorizing God's Word is a vital tool for believers. Scripture helps us understand God's ways so that we can apply his principles to our lives. We can also use Scripture in prayer, and once we know the Word of God well, we can share it.

Scripture memorization is valuable for our personal growth as believers and even more so for sharing Christ with others.

For this exercise, the goal is Scripture memory through scripturedoodling. When the Word of God is put into pictures, it gives us a mental image to return to in our work of memorization. Take a moment to add visual elements to any key words in the verse displayed on the next page: maybe a person to represent "I," a Bible for the Word of God, or even a magnifying glass to represent "hidden." You can also emphasize key words through color and pattern. Then add the finishing touches to your drawing with a border and decorate the letters with any extra doodles you wish. Be sure to try this exercise again with a verse you feel inspired to memorize. You can even scripturedoodle on index cards or sticky notes and place them where you'll see them often.

Psalm 119:11

I HAVE

hidden

YOUR WORD

IN MY ♡

that I might not

sin against you.

REVIVE THE HEART

You, God, are my God,
earnestly I seek you;
I thirst for you,
my whole being longs for you,
in a dry and parched land
where there is no water. (Psalm 63:1)

Have you ever felt exhausted and thought something like, **My heart is tired and I need someone to revive it**? Often the demands of life become overwhelming and we try to take on everything by ourselves. In those moments, it's important to remember that Christ is our life giver and that without him we are hopeless. The cross and the Word of God are two symbols that remind us that God is our source of life.

On the page to the right are a heart, cross, and Bible. You'll notice they aren't connected. However, we can receive life from God only when we are connected to him. So your job is to get creative and connect the heart to these two life-giving things. You can simply use color, or you may use more detail and draw cords or links connecting all three.

Take time to write the words of the verse inside or above the heart, and fill the space around it with some of the doodles and borders you created earlier in this book.

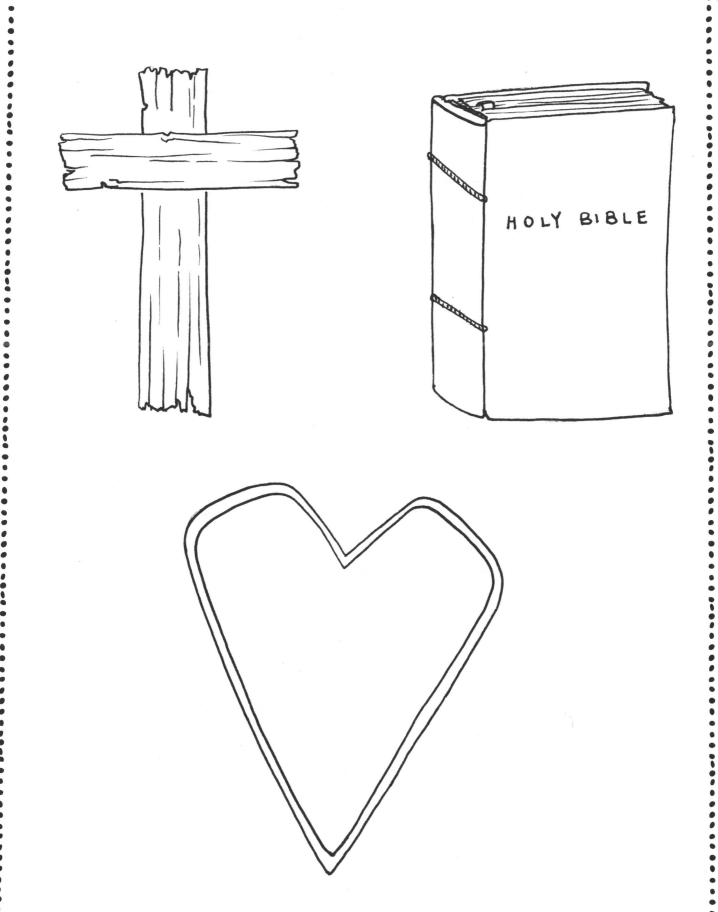

REST

Do you find it difficult to rest? I do, partly because I always feel behind on my to-do list and partly because I have inherited this beautiful thing from my mother called "I wake up in the middle of the night with ideas, and then I can't go back to sleep because I keep thinking about how to execute them in a perfect manner."

All to say ... sometimes I just feel tired. This exercise is focused on emptying your worries and concerns and taking the time to rest. After all, God has called us to do just that.

Come to me, all who labor and are heavy laden, and I will give you rest. Take my yoke upon you, and learn from me, for I am gentle and lowly in heart, and you will find rest for your souls. For my yoke is easy, and my burden is light. (Matthew 11:28–30 ESV)

I've created two things for you on the next page. First, a jar to hold your worries and your cares—your **heavy burdens**. Inside the jar, using words or doodles, demonstrate the things that are worrying you. If your schedule is stressing you, maybe draw a planner in the jar. Get creative.

Once you have filled the jar, move on to the bed. Decorate it with your dream bedding set. Think of the colors or patterns you might use. As you color, remind yourself that God is our true source of rest and that he desires to be the jar where we put all our worries and cares. Imagine yourself taking the nap of a lifetime on that cozy bed. And when you are finished, if you have twenty minutes free, take a nap!

Further reading: Matthew 11:25–30 and Psalm 62:1–2

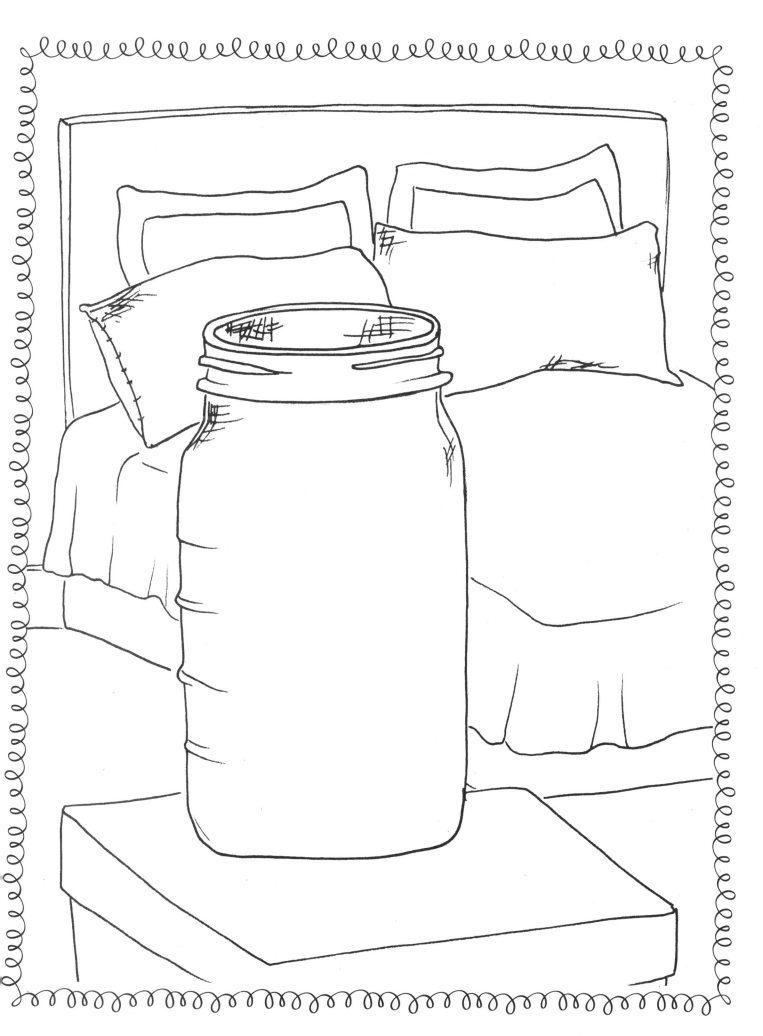

FRUIT THAT LASTS

I am the vine; you are the branches. If you remain in me and I in you, you will bear much fruit; apart from me you can do nothing. If you do not remain in me, you are like a branch that is thrown away and withers; such branches are picked up, thrown into the fire and burned. If you remain in me and my words remain in you, ask whatever you wish, and it will be done for you. This is to my Father's glory, that you bear much fruit, showing yourselves to be my disciples.

As the Father has loved me, so have I loved you. Now remain in my love. (John 15:5–9)

This passage is so true. We must be connected to the vine in order to bear fruit, and Jesus is the vine. Apart from him we can do nothing. In any fruit, the plant is the source of the growth. When disconnected from the vine, a strawberry will die, yet the vine will continue to produce other fruit because the vine is the source of life. So it is with God.

For this exercise, continue the picture on the right by connecting the strawberry to the vine. Then add more fruit and leaves and vines. Be sure to keep them connected. Next choose a phrase or verse from the passage above that speaks to you. Doodle it into your picture. A neat way to do so is to make the letters of the words look like the vine.

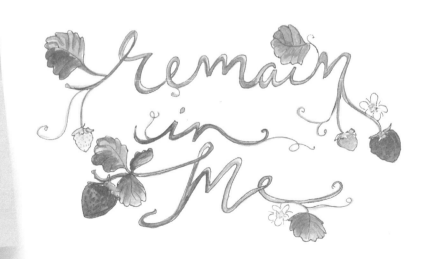

MEASURING UP

Do you measure yourself against others, or do you measure against the Word of God? Perhaps you spend time comparing your social status, financial situation, or family to that of others. God has asked us to evaluate ourselves by his principles alone, not ours. Here are some great verses highlighting the things of God:

Wherever there is jealousy and selfish ambition, there you will find disorder and evil of every kind. (James 3:16 NLT)

Obviously, I'm not trying to win the approval of people, but of God. If pleasing people were my goal, I would not be Christ's servant. (Galatians 1:10 NLT)

See also Philippians 2:3; 4:8; 1 Timothy 6:6–8.

There are two rulers on the right, each with something written on them. Create two more rulers underneath them. Make one of them broken, and write on it something you currently measure by that needs to be broken. After that, draw another ruler that is unbroken and doodle on it one of the verses above that speaks life to your heart in the area of measuring yourself against others. The first two rulers show an example of this. Feel free to create a doodle border around the page to fill out the rest of the space.

Grace

COM PARISON

GENTLE WORDS

> *A gentle tongue is a tree of life,*
> *but perverseness in it breaks the spirit. (Proverbs 15:4 ESV)*

How are you at speaking to others? Often it is easy to speak to everyone except those who are closest to us. The ones we love the most are the ones who get the worst version of us. Ephesians tells us how we should speak the truth:

> *We will speak the truth in love, growing in every way*
> *more and more like Christ, who is the head of his body,*
> *the church. (Ephesians 4:15 NLT)*

On the page to the right, bring the tree trunk and branches to life with such things as leaves, buds, flowers, and even fruit. If you want to push yourself a bit creatively, figure out a way to work a few gentle words into the greenery of the tree. Add one of the verses above to finish off your scripturedoodle.

Examples are drawn below to help you get started.

"A Gentle tongue is a Tree of Life"
—Proverbs 15:4

PRAYER APPOINTMENT

Rejoice always, pray continually, give thanks in all circumstances; for this is God's will for you in Christ Jesus. (1 Thessalonians 5:16–18)

Look up some of these verses on prayer:
Mark 11:24; Ephesians 6:18; Philippians 4:6–7; James 5:14–16.

Prayer is such a precious gift that God has given us, but making time to devote ourselves to it can be difficult. The purpose of this exercise is to spend some special time in creative prayer with God.

Begin by choosing one of the verses about prayer and making a word-style scripturedoodle of it in the empty box on the next page. Choose key words to emphasize by using size, color, and design. Then continue by coloring in and filling out the prayer prompts in the rest of the boxes. As you continue your creative prayer time, fill the margins of the page with doodles, colors, and patterns.

THANK YOU GOD

for: _____

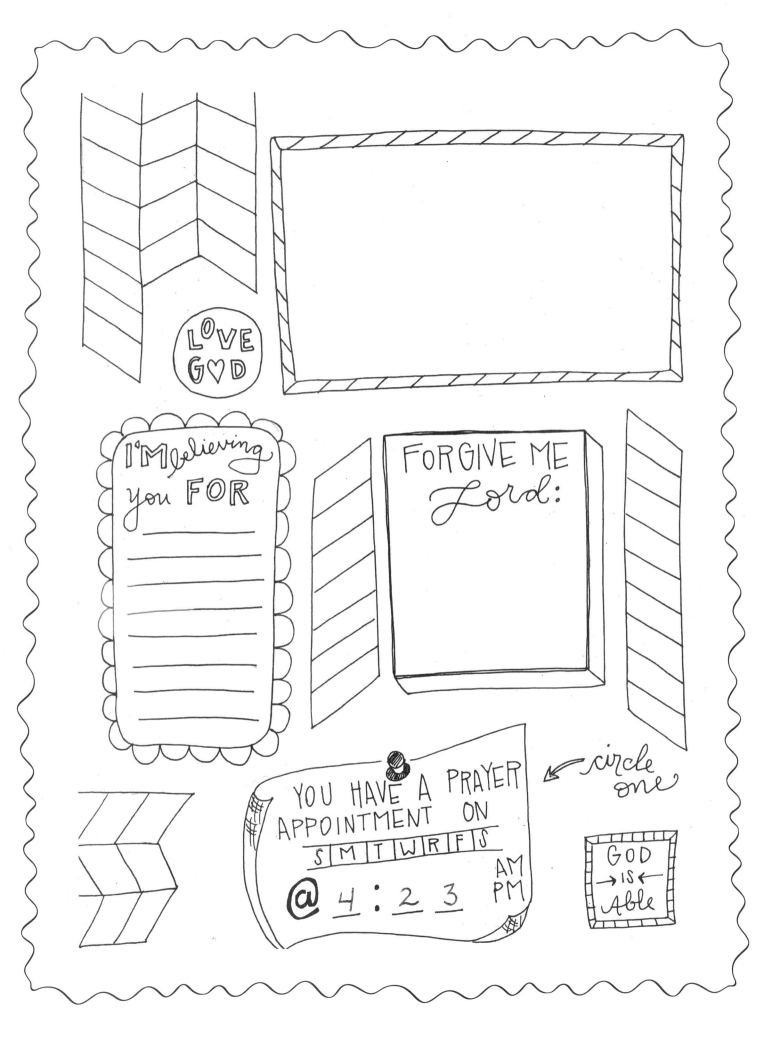

OFFERING

Mark tells the story of one woman who offered everything she had to God:

> Jesus sat down opposite the place where the offerings were put and watched the crowd putting their money into the temple treasury. Many rich people threw in large amounts. But a poor widow came and put in two very small copper coins, worth only a few cents.
>
> Calling his disciples to him, Jesus said, "Truly I tell you, this poor widow has put more into the treasury than all the others. They all gave out of their wealth; but she, out of her poverty, put in everything—all she had to live on." (Mark 12:41–44)

Even though it was a small offering compared to others, Jesus said she brought the greatest offering. We must remember that it's not for us to determine the value of our offering. Our job is solely to bring it to God. He can do so much with open hands and a willing heart. The widow in the above passage brought what seemed like a small sacrifice, but for her it was everything, and many people for thousands of years would remember it. How beautiful!

What are "two small coins" you could offer to God? Is there something you think is not good enough or is too small to offer? Maybe a skill or your finances or your marriage? Whatever it is, offer it to God. On the page to the right, there is a small offering symbolic of what the widow in the story gave. Continue this drawing by adding to the picture, growing from the coins. Sketch things that are symbolic of your offering or any offering. It could be money, but it could also be your time and resources. Do your best to keep everything connected by lines in the picture. You can do this with filler doodles such as stripes, shapes, patterns, and blocks of color. Let it grow, so to speak, and see what you come up with in the end.

MOVE OUT DOUBT

There are many forms of fear, and doubt is one of them. When it comes to faith, there is just no room for doubt. It clouds everything we know to be true about the character of God. It also eats away at our dreams and keeps us from taking risks in our faith. The book of James holds some good truth on the subject:

If any of you lacks wisdom, you should ask God, who gives generously to all without finding fault, and it will be given to you. But when you ask, you must believe and not doubt, because the one who doubts is like a wave of the sea, blown and tossed by the wind. That person should not expect to receive anything from the Lord. Such a person is double-minded and unstable in all they do. (James 1:5–8)

The phrase "move out doubt" might sound cheesy, but hopefully it will become a catchphrase you can repeat to yourself when you begin to doubt God in a situation. The Enemy knows the power of faith and believing God; that's why he throws things such as doubt at us. Let's not let him win.

For this exercise, there is a moving truck for you to fill with the boxes of doubt in your life. Write on each box the statements of doubt you hold on to. If you need more boxes, go for it; get rid of it all. Ask God for healing from doubt. He is able! As you create, feel free to add things to the background, such as trees or sky. You can also write the verse or a portion of it somewhere in the picture. Be sure to finish with color in the medium of your choice.

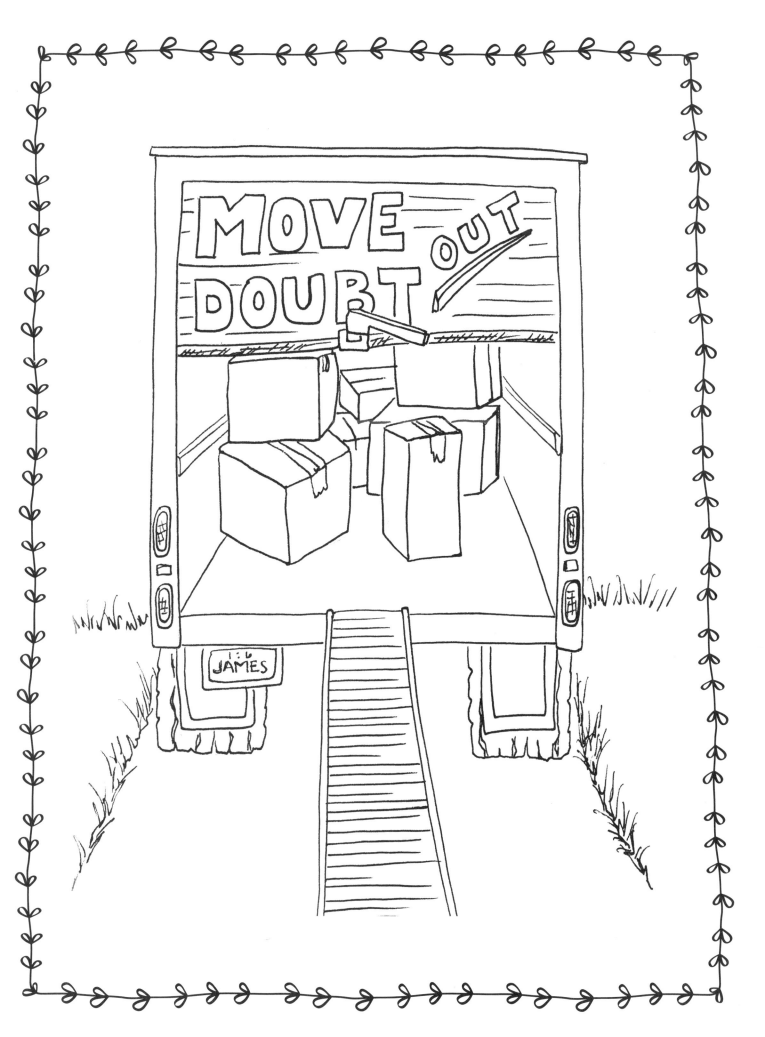

JOYFUL PATTERNS

This exercise is a free space of digging into the Word of God and experimenting with color and pattern. Joy is a powerful and contagious thing. Here's a great verse about it:

> *Weeping may endure for a night,*
> *But joy comes in the morning. (Psalm 30:5 NKJV)*

Start this exercise by adding some final embellishments to the word joy below. Choose one color that means joy to you, and then create a pattern within it that feels joyful.

Once you finish the word joy, move on to another word you love. Write the word large on the next page in a classic block letter. Fill each letter of your word with a playful pattern in whatever color you think of when you hear that word. For example, the word **love** might be red, and **dream** might be blue. You get the idea. After you finish your patterns, find a verse in the Bible that talks about your word. An easy way to do this is to Google "Bible verses about _____" or use the concordance in your Bible. Finish your scripturedoodle by writing the verse you selected in the blank space around your big word.

Share your finished product online using #scripturedoodlejoyfulpatterns and see what others have posted as well!

DISCIPLESHIP

Jesus came to make disciples, and as Christ followers, making disciples should be something we do too. If we forget discipleship, we are missing something huge. Jesus's last words to his followers were this:

> *Go and make disciples of all nations, baptizing them in the name of the Father and of the Son and of the Holy Spirit, and teaching them to obey everything I have commanded you. And surely I am with you always, to the very end of the age.*
> *(Matthew 28:19–20)*

Succulents are quite the cactus. They are beautiful and require little care, and one of their best qualities is that they duplicate themselves by design. When you plant a succulent, within a few short weeks another plant can start budding from a callused leaf. And with a little help from a gardener, this process will take place again and again. In the same way, as a disciple of God, you are designed to make more disciples.

To the right is the beginning of a succulent garden with a few "disciples" in it. Add more succulents growing from the few. Create as many as you'd like. A full garden would be lovely. I've included a quick succulent-drawing tutorial on the next page to help you. Include the verse somewhere on the page and doodle away on the flowerpot too. As you sketch, don't worry if the succulents don't all look the same, because neither do we. We are one-of-a-kind creations made by God, and we all need a little discipling. Have fun!

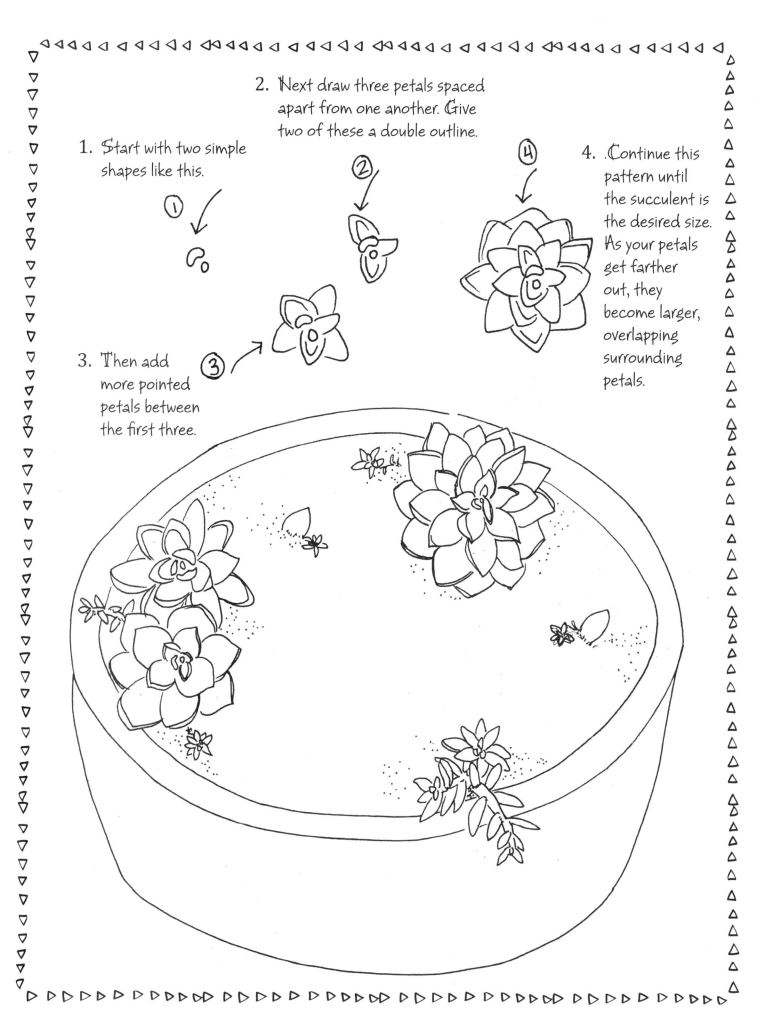

1. Start with two simple shapes like this. ①

2. Next draw three petals spaced apart from one another. Give two of these a double outline. ②

3. Then add more pointed petals between the first three. ③

4. Continue this pattern until the succulent is the desired size. As your petals get farther out, they become larger, overlapping surrounding petals. ④

BEATIFUL THINGS

He has made everything beautiful in its time. He has also set eternity in the human heart; yet no one can fathom what God has done from beginning to end. (Ecclesiastes 3:11)

This is the finest truth. The life cycle of a butterfly is the perfect way to illustrate this. Like a caterpillar in its cocoon, the form of the insect can appear unattractive, but in its time, beauty comes. God makes everything beautiful in its time, even us. Some days this is hard to believe due to circumstances or how we see ourselves, but these words are true and this life is his work. Let's find rest in that today.

Add the words of Ecclesiastes 3:11 to the scripturedoodle drawn, and then spend time coloring the picture. While doing so, think about the places of your heart where God has done great work and express your thanks to him.

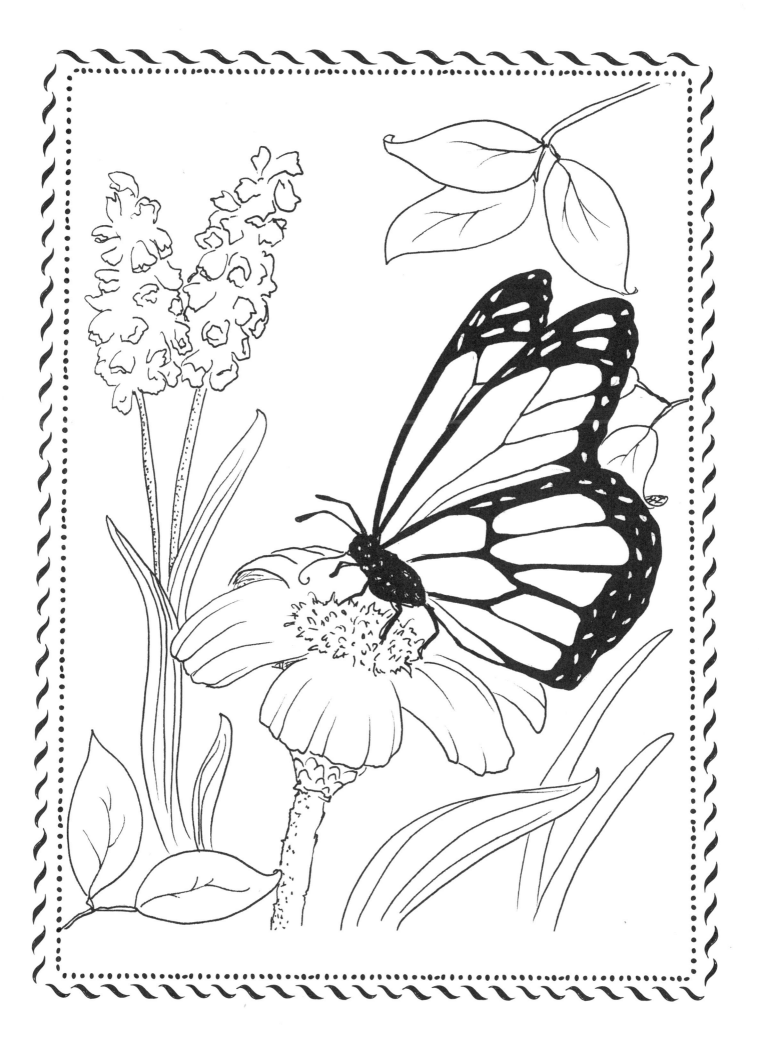

EXPRESS YOUR HEART

There is value in expressing your heart to God. He wants to hear your deepest desires and your gratitude. So much of the Bible confirms this:

> *Do not be anxious about anything, but in every situation, by prayer and petition, with thanksgiving, present your requests to God. And the peace of God, which transcends all understanding, will guard your hearts and your minds in Christ Jesus. (Philippians 4:6–7)*
>
> *This is the confidence we have in approaching God: that if we ask anything according to his will, he hears us. (1 John 5:14)*
>
> *The LORD is near to all who call on him,*
> *to all who call on him in truth. (Psalm 145:18)*
>
> *Call to me and I will answer you and tell you great and unsearchable things you do not know. (Jeremiah 33:3)*
>
> *The LORD has heard my cry for mercy;*
> *the LORD accepts my prayer. (Psalm 6:9)*

Take time today to write out a prayer to God in the basket of the hot air balloon, which can signify your message traveling to heaven. Don't be afraid to express your whole heart to God, the pretty and the ugly, and be vulnerable. Remember that he listens to us and desires to answer when we call. Once you finish writing your prayer, fill the balloon with patterns and color. Keep in mind the beautiful bright colors that often adorn a hot air balloon and use those for inspiration. As you add patterns, try to alternate your designs throughout the space. Then choose one of the verses above to integrate into your picture, maybe in the sky or even in the design of your balloon.

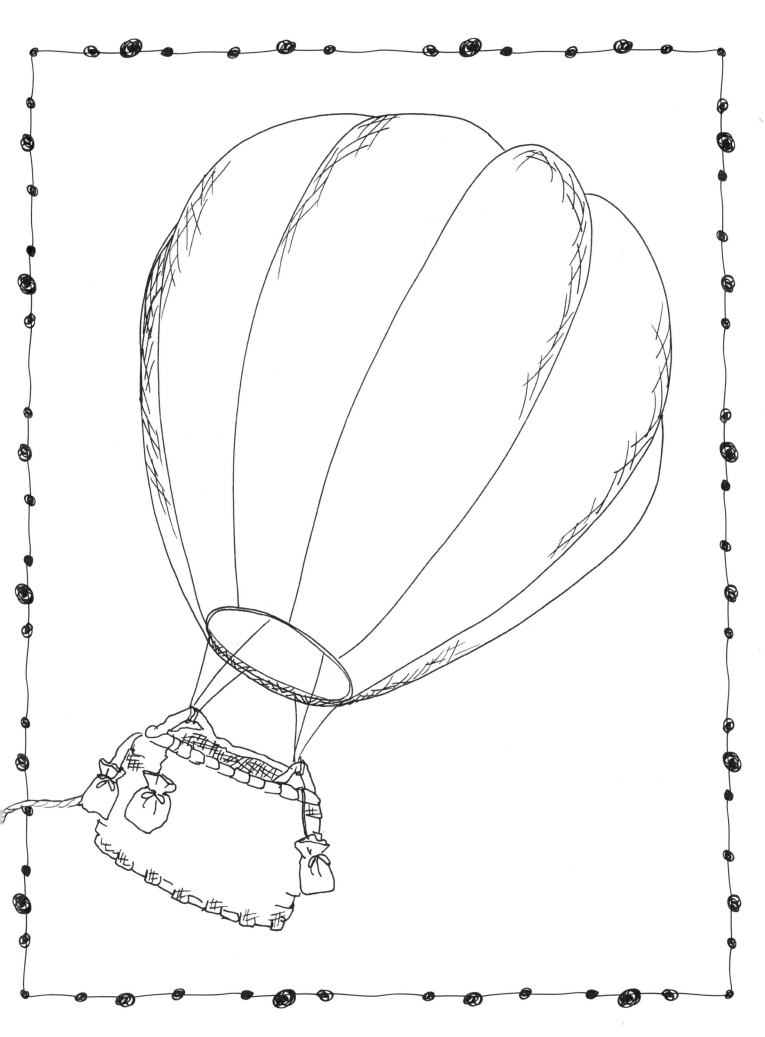

GOOD GIFTS

*Every good and perfect gift is from above,
coming down from the Father of the heavenly
lights, who does not change like shifting shadows.
(James 1:17)*

*The wages of sin is death, but the gift of
God is eternal life in Christ Jesus our Lord.
(Romans 6:23)*

*God so loved the world that he gave his one and
only Son, that whoever believes in him shall not
perish but have eternal life. (John 3:16)*

God is the giver of the best gifts! Every good thing comes from him. What is one gift you are sure came from the Lord? Can you imagine your life without it?

Draw a gift box on the page to the right, and then draw the gift that came to mind or something that symbolizes it. For example, if it's your family, you could draw a home instead of people. Feel free to use words in your picture or instead of a picture if you so desire. Be sure to draw a bow on your box. Once your picture is finished, add the text of one of the verses around your box like a border. You can refer to the border exercise near the front of this book if you need a little inspiration. Color in your picture. As you create, speak your thanks to God for his great gifts.

GOD IS LIGHT

Only light can penetrate darkness. With one strike of a match, light can appear and pierce the dark space surrounding it. First John 1:5 says, "The light shines in the darkness, and the darkness has not overcome it" (ESV). What a visual understanding of God's character. He literally brings light. How incredible!

> The people living in darkness
> have seen a great light;
> on those living in the land of the shadow of death
> a light has dawned. (Matthew 4:16)

Think about a time when God brought light to your darkness and how his presence changed the situation. What was the experience like? What was the match that sparked the light for you?

On the following page, fill the entire space with what represents light to you. You might choose to focus on one thing, such as a sunrise, or you could make a compilation of different things. Keep in mind the element of repetition you used in the discipleship exercise. You could draw multiple lightbulbs that are each a different size and shape. This will bring variety to your picture. As you add color, you can use many different tones of yellow. Even oranges and blues too! Somewhere in your picture, hide the text of one of the above verses.

SCRIPTURE CARDS

There is something so powerful about seeing the Word of God throughout the day. A simple way to do this is by writing Bible verses on small cards and putting them in your home, office, or car, where you'll see them often.

For this exercise, fill in and decorate the Scripture cards on the page to the right to remind you of God's truth. Once you're done with those, make some of your own using blank index cards or cut paper. Use color and pattern to spice them up. You might try highlighting key words in the verse, which is a great way to make the heart of the verse stand out. You can even give a few cards to a friend for encouragement. Or better yet, share them on social media and tag your friends @scripturedoodle. Below are a few verse suggestions, but feel free to find a verse that speaks to your needs in this season.

Do not fear, for I am with you;
 do not be dismayed, for I am your God.
I will strengthen you and help you;
 I will uphold you with my righteous right hand. (Isaiah 41:10)

I have told you these things, so that in me you may have peace. In this world you will have trouble. But take heart! I have overcome the world. (John 16:33)

I keep my eyes always on the LORD.
 With him at my right hand, I will not be shaken. (Psalm 16:8)

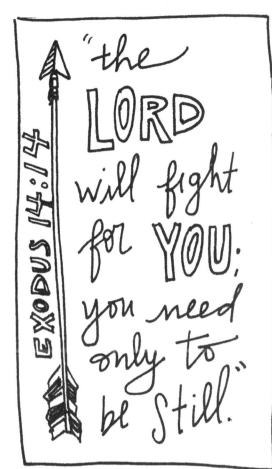

"the LORD will fight for YOU; you need only to be still."

EXODUS 14:14

Bear fruit In keeping with Repentance -Matt. 3:8

HOSPITALITY AND SERVING

It becomes easy to make a laundry list of excuses for why there isn't time to serve others. We all have those same, often valid reasons why serving and hospitality shuffle to the bottom of our lists. But God's Word keeps the balance of this life in perspective. Check out this passage from 1 Peter:

> *Above all, love each other deeply, because love covers over a multitude of sins. Offer hospitality to one another without grumbling. Each of you should use whatever gift you have received to serve others, as faithful stewards of God's grace in its various forms. If anyone speaks, they should do so as one who speaks the very words of God. If anyone serves, they should do so with the strength God provides, so that in all things God may be praised through Jesus Christ. To him be the glory and the power for ever and ever. Amen. (1 Peter 4:8–11)*

Love deeply, he says, and show hospitality without grumbling. That is the key: deciding to have joy as we serve and love one another. What might happen if we all resolved to show hospitality and serve even when we "don't have time"?

On the page to the right, there is one open hand holding a cupcake. Start this scripturedoodle by decorating it with your favorite toppings, and then fill the other hand with something that says "hospitality" to you—maybe a cup of coffee or a sweet treat. Once you finish the picture part, add some of the verse from above to remind yourself of the value of hospitality. You can turn your letters into sweet treats, perhaps by making an "o" look like a doughnut. Here are a few examples to get you started:

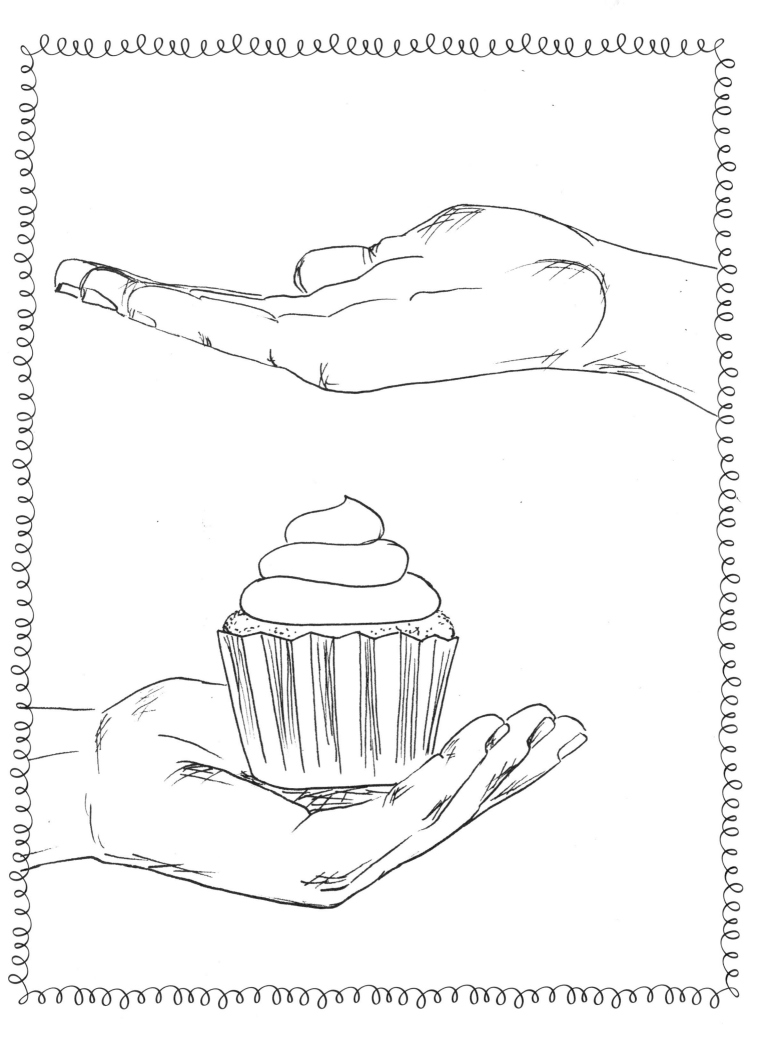

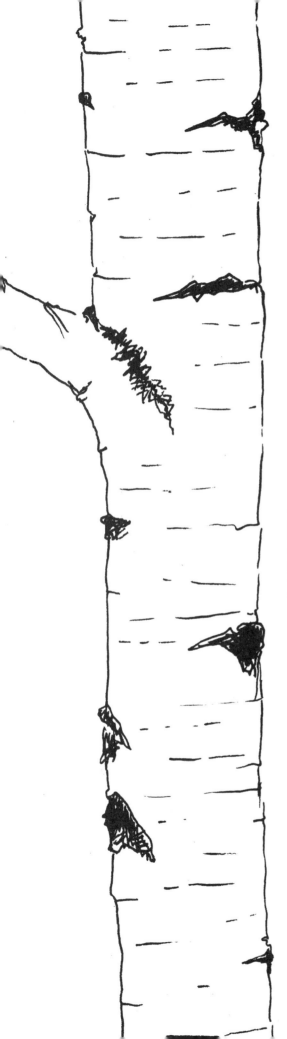

SEEK AND FIND

You will seek me and find me when you seek me with all your heart. (Jeremiah 29:13)

This verse comes with a promise, and at the same time, it expects much of us: "Seek me with your **whole** heart and you will find me."

Imagine yourself traipsing through a forest in search of some incredible nature view or hidden treasure. The seeking is hard work, but when you find the treasure, the reward is unmatched! For this exercise, you get to make a little seek-and-find of your own.

On the next page is an outline of four birch trees. Fill the trees with doodles. Use lines and shapes and patterns—anything! But while you create, see if you can hide the verse in the picture in a way that will require a little seeking in order for it to be found. There are a few doodle examples below that you can also include in your picture. Spend some time adding color to complete your scripturedoodle.

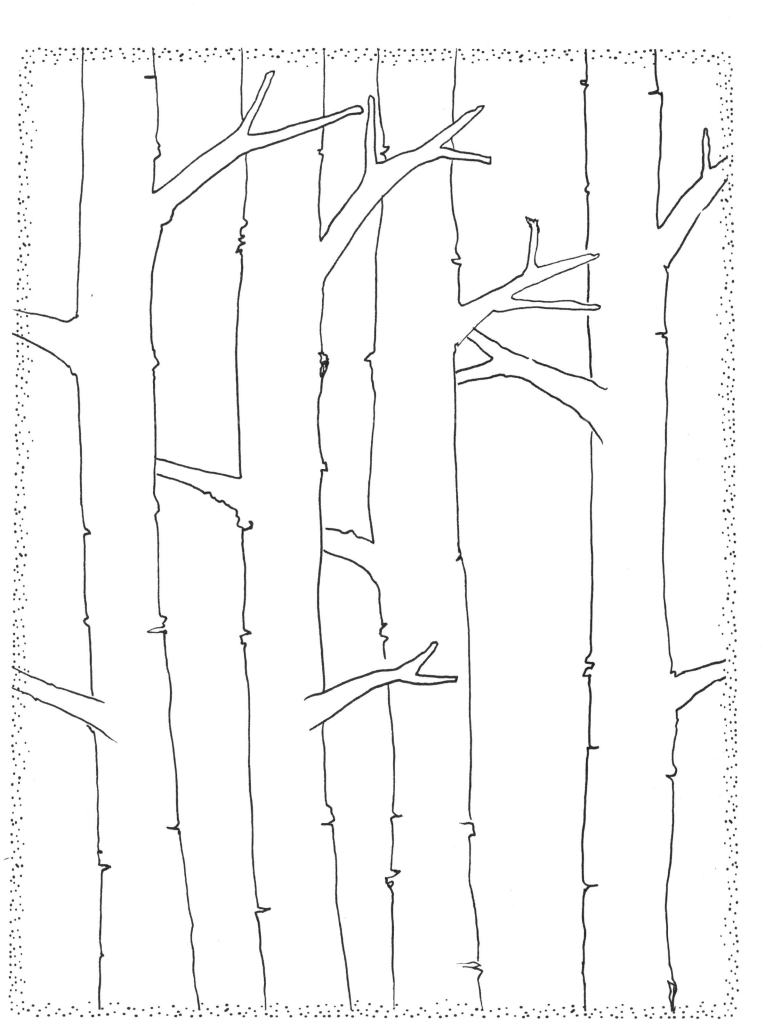

IN HIS SHADOW

There must be a light source in order to create a shadow. If there is no light, there is no shadow. Light and shadow have the ability to transform art in a way like nothing else, just like God's light transforms us like nothing else can.

> Whoever dwells in the shelter of the Most High
> will rest in the shadow of the Almighty.
> I will say of the LORD, "He is my refuge and my fortress,
> my God, in whom I trust."
>
> Surely he will save you
> from the fowler's snare
> and from the deadly pestilence.
> He will cover you with his feathers,
> and under his wings you will find refuge;
> his faithfulness will be your shield and rampart. *(Psalm 91:1–4)*

In art, the source light affects where the shadow casts. We'll practice creating shadow in this exercise, so a pencil or colored pencils will work well. On the next page, create a shadow under the wings. How will the shadow from the wings cast on the ground? That depends on where the light is. If the light is coming from the top left, then the shadow will be on the bottom right. So create a light source wherever you choose in the picture. It could be a sun or a lightbulb. Then get started on your shadow. Add your name or a drawing of yourself under the wings and maybe a border of feathers signifying God's protection over you. Write the verse creatively in the empty space left over. Below are a few shading tips and sample drawings for you to work from.

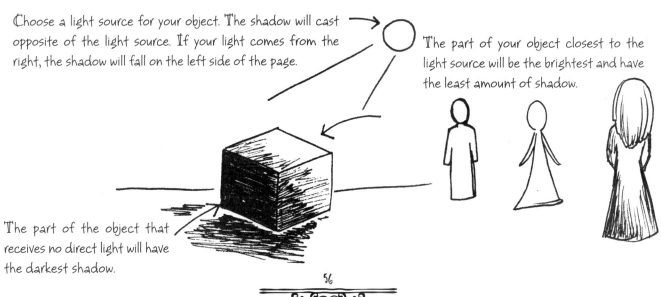

Choose a light source for your object. The shadow will cast opposite of the light source. If your light comes from the right, the shadow will fall on the left side of the page.

The part of your object closest to the light source will be the brightest and have the least amount of shadow.

The part of the object that receives no direct light will have the darkest shadow.

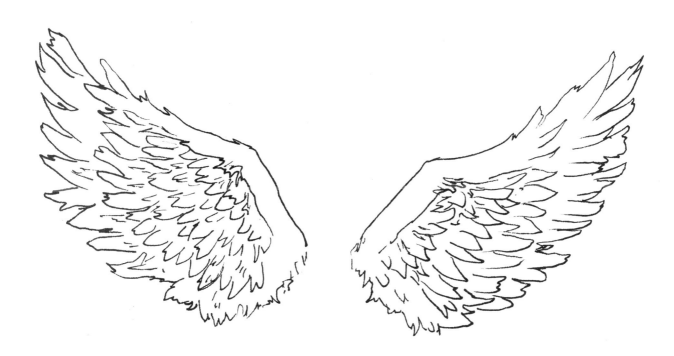

NO OTHER NAME

The thing about God is that there is no one like him—absolutely no one. He is it: the one answer to all our problems, the creator of love and this amazing story, and the one who made the world, who would give up everything for a bunch of messed-up people because, for some crazy reason, **he loves them**. There. Is. No. Other. Name.

> *Salvation is found in no one else, for there is no other name under heaven given to mankind by which we must be saved. (Acts 4:12)*

On the next page, fill the entire space with names of God from the list below. (You can do an online search for more if you want.) As you create, consider the whole composition of your page. How are things visually fitting into one another? You might start with one name large and in the center of the page to help you begin. Then as you add more names, you can think of the words as shapes and plan out the space. For example, draw a circle and fit the letters of the word tightly in the space of the circle. Then erase the outline of the circle once you're done. You can even turn the name into a doodle. If you choose **Tree of Life**, you can make an actual tree and write **of life** around it. Once you have most of the names written, fill the empty space of the page with different patterns, doodles, and shapes and maybe even a border. Don't forget color!

Names of God:

Father

Prince of Peace

Jesus

Adonai

Giver of Life

Abba

Holy Spirit

Begin with a shape and fill the inside with your words. Then erase the outline shape and fit other words around it.

Once you draw your shape, erase this outline.

Turn the name into a doodle by choosing a visual word and replacing it with a picture.

RIVERS IN THE DESERT

Remember not the former things,
nor consider the things of old.
Behold, I am doing a new thing;
now it springs forth, do you not perceive it?
I will make a way in the wilderness
and rivers in the desert. (Isaiah 43:18–19 ESV)

Do your current circumstances seem like a desert? God wants us to leave the past behind, and we expect him to do something new in our lives. He makes a way in our "wilderness" circumstances.

Is there a desert in your current circumstances? See the desert space on the next page. As you pray and practice believing God, work to bring this desert to life. Add some waterways and then new life budding from the land around it, because where there is water, life is present. Put the text of the verse in the picture however you see fit.

You might start with something like this:

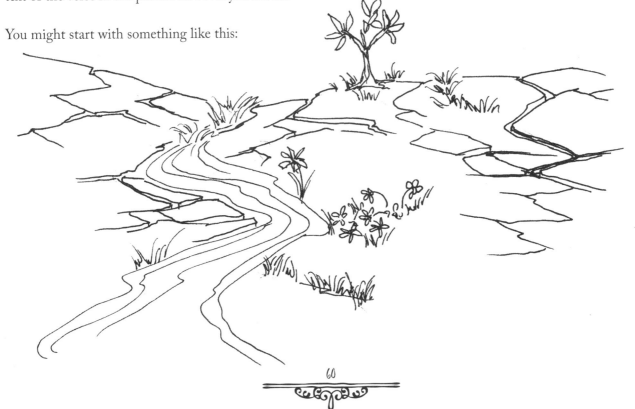

IMMEASURABLY MORE

[He] is able to do immeasurably more than all we ask or imagine, according to his power that is at work within us.
(Ephesians 3:20)

There is power in hearing a passage over and over and seeing it in front of you on a regular basis. When we wrap our hearts around the idea of immeasurably more, it will be a game changer in our dreams and what we believe about God. What could Ephesians 3:20 mean for you?

Let's make an abstract-style scripturedoodle here. There aren't many visual words in this verse, but think through what it could look like. The phrase "immeasurably more" might make you think of your dreams coming true. What would that look like? Or is there a blessing God has given you already that feels like Ephesians 3:20? If so, draw that. If you need a little help deciding what to draw, spend a moment thinking of different visual things related to your dream. Start by lettering the verse in the middle of the page. Play with size and style as you lay it out, and emphasize key words within the text. Then draw doodles around it that represent **immeasurably more** than what you imagine God can do in your life.

HONEYCOMB

*Gracious words are a honeycomb,
sweet to the soul and healing to the bones. (Proverbs 16:24)*

As a honeycomb is designed by God, so is the element of grace necessary in his family. Honey is sweet and good for the body, and so are gracious words. They bring life to the receiver. Have you ever been on the other side of gracious words? Especially when you didn't deserve them? They are such sweet gifts.

For this exercise, there's the start of a honeycomb created for you. Draw more hexagons of honeycomb and fill the space inside each shape with gracious words—words that bring life. You can start with these:

Then write more of your own if you'd like. Get creative with your lettering. You can add even more bees buzzing around the picture, and be sure to fill the page with color and write in the verse from Proverbs. Let these gracious words and this verse remind you to give grace to someone the next time you have an opportunity to do so.

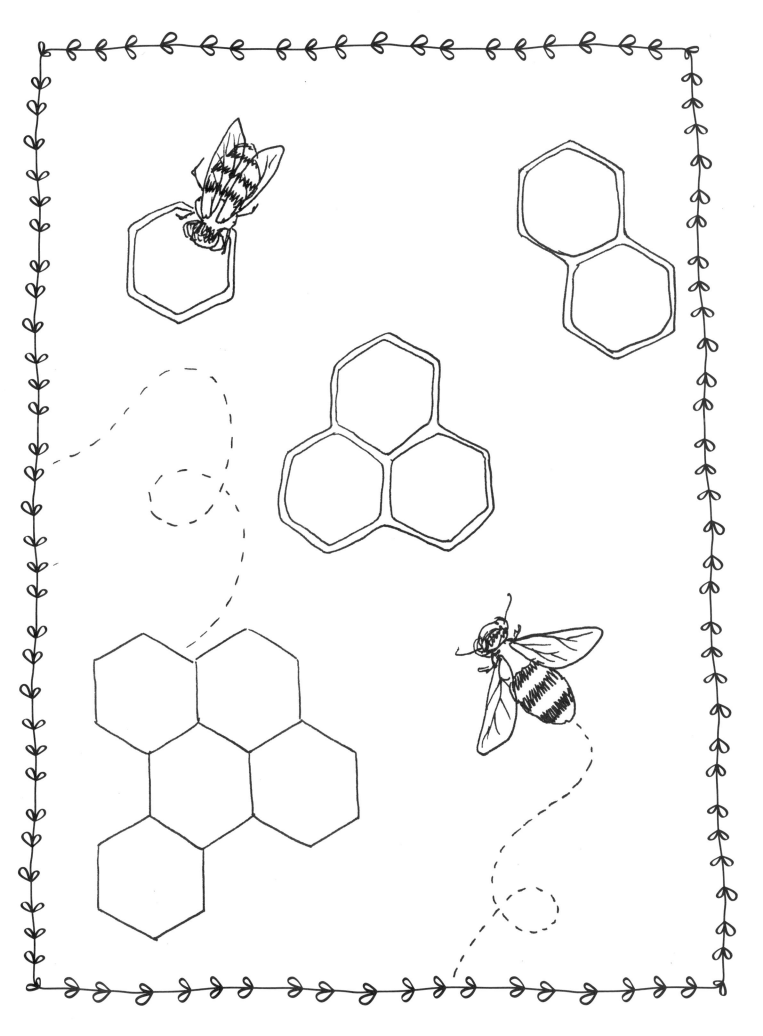

EMOJIS

> *The joy of the LORD is your strength. (Nehemiah 8:10)*

Emojis have come to play a very large role in today's world. Some people feel ill equipped to send a text without them, as if they don't trust actual words to convey their emotions. How about you? Do you share the same fondness for these small, emotion-filled characters? If not, it's okay, and maybe you'll enjoy them more after this exercise.

Try your hand at creating a scripturedoodle from a verse of your choosing, strictly using emojis and nothing else. This may be a stretch for you, but think of it as a fun activity to keep you fresh on the gospel as well as the world around you. Look at the example below to help you get inspired and excited.

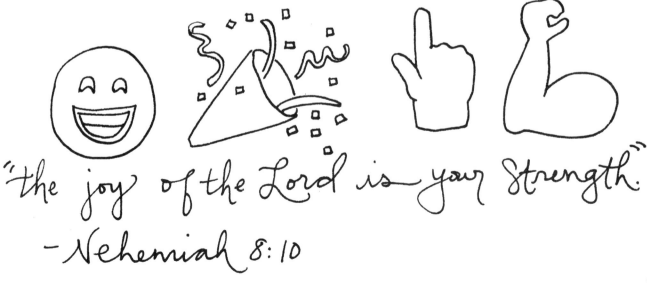

"the joy of the Lord is your Strength."

— Nehemiah 8:10

BE POSITIVE

> *Do not let any unwholesome talk come out of your mouths, but only what is helpful for building others up according to their needs, that it may benefit those who listen. (Ephesians 4:29)*

"Be positive" may be one of those cheesy sayings that gets stuck in our heads, but it's such a good reminder. Think of the power of our words: we can't always control the thoughts that come into our heads, but we can control the words that come out of our mouths. Unwholesome talk hurts people, but positive words help them!

For this exercise, the focus is the negative space. We're going to turn it positive. In artwork, the negative space is what surrounds the objects in a picture, including between objects. That is what we'll create in this exercise: art in the negative space.

Fill every square inch of the negative space around this important phrase. Just doodle it; make it bright and fun. Practice patterns, squiggles, dots, and anything else you'd like. As you draw, remind yourself of the power of your words. They set the tone for the space around you, whether positive or negative. Choose to build others up according to their needs. You will always be glad when you do.

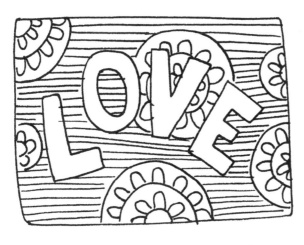

BE POSITIVE

OUR EYES

The eye is the lamp of the body. If your eyes are healthy, your whole body will be full of light. But if your eyes are unhealthy, your whole body will be full of darkness. If then the light within you is darkness, how great is that darkness! (Matthew 6:22–23)

You never see the top and bottom of the iris at the same time. Be sure to add the inside rim of the eye socket.

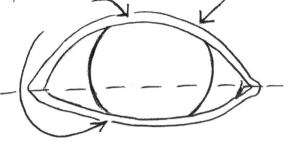

Eyelashes are smaller the closer you get to the nose. The way you center the iris in the eye socket communicates where the eye is looking.

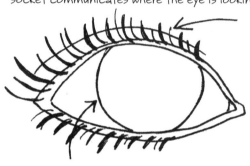

It is often said that the eyes are the window to the soul. Picture someone who is sad. If you don't see anything but his eyes, you can still see how he feels, merely by how his eyes look. In artwork, eyes carry the most emotion; they bring a piece of art to life. And in life, our eyes communicate the condition of our hearts to others. What do your eyes tell people about your soul? Are they healthy? As believers, we bring Jesus to the world, and often it starts with our eyes—what they see and what they communicate to others.

Draw the top of the eyelid. The outer rim of the iris will be dark, and the inside near the pupil will be light. Add a highlight to the pupil with a small white circle or square.

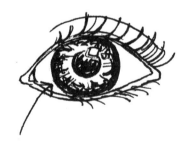

After reading the eye-drawing tips and practicing a bit, move to the next page and go for it! Draw a set of eyes or just one. Take your time and start in pencil to make it easy as you fine-tune your drawing. To make it a scripturedoodle, add the text of the verse to your final picture. It's okay if your eyes aren't perfect. Remember that your purpose here is worship and exploring your own creativity.

PSALMDOODLE

Now it's time to put your scripturedoodle skills to work! Read the following passage and choose one verse that stands out to you. Once you decide on a verse, choose a key word in the text that brings an image to mind and start by drawing that.

> The LORD is my shepherd, I lack nothing.
> He makes me lie down in green pastures,
> he leads me beside quiet waters,
> he refreshes my soul.
> He guides me along the right paths
> for his name's sake.
> Even though I walk
> through the darkest valley,
> I will fear no evil,
> for you are with me;
> your rod and your staff,
> they comfort me.
>
> You prepare a table before me
> in the presence of my enemies.
> You anoint my head with oil;
> my cup overflows.
> Surely your goodness and love will follow me
> all the days of my life,
> and I will dwell in the house of the LORD
> forever. (Psalm 23)

Once you have your first image drawn, think of any other visual elements contained in the verse that you would like to include in your picture. You can also incorporate the words of the text into the picture in a creative way.

the Lord is my Shepherd

TASTE AND SEE

> *Taste and see that the LORD is good;*
> *blessed is the one who takes refuge in him. (Psalm 34:8)*

Take a minute to breathe in this bright and true scripture. This verse brings to mind the sweetness of God and the blessings he gives. God truly is our spiritual food to taste and see.

For this activity, a place setting has been made for you. Fill the plate with good food that reminds you of the Father. For each food, consider why you chose it. It could be a metaphor, or maybe you chose it just because it's God's creation. You might choose a food because it's your favorite and you are thankful God created it for your enjoyment. Or, for example, you could choose a strawberry to represent the many fruits of the Spirit. Once you draw and color all the food on your plate, write the verse around the rim of it, either on the plate itself or in the blank surrounding space. Finish with a food-inspired border if you wish.

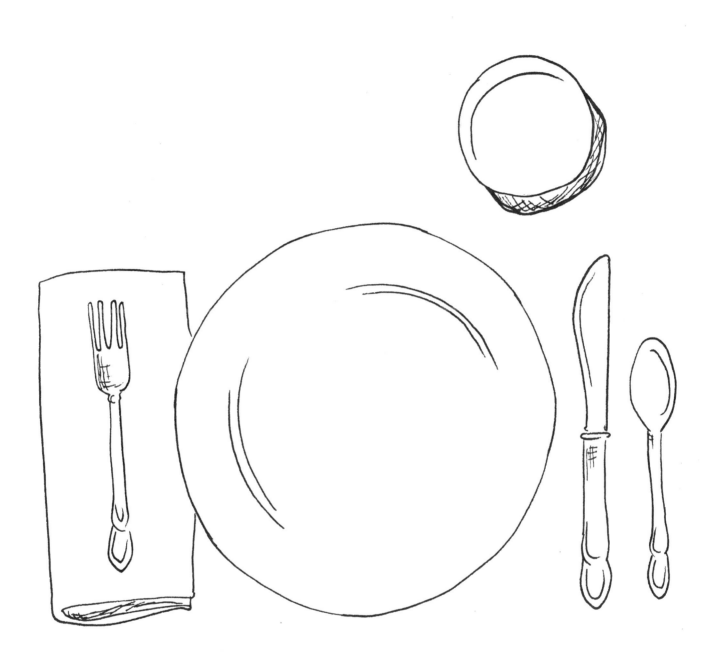

FRAME OF MIND

Have you ever been so tired that you just wanted to quit? Perhaps it was out of sheer exhaustion or because you sensed that everything was working against you. Surely everyone has felt this way at some point.

> *Do you not know?*
> *Have you not heard?*
> *The LORD is the everlasting God,*
> *the Creator of the ends of the earth.*
> *He will not grow tired or weary,*
> *and his understanding no one can fathom.*
> *He gives strength to the weary*
> *and increases the power of the weak.*
> *Even youths grow tired and weary,*
> *and young men stumble and fall;*
> *but those who hope in the LORD*
> *will renew their strength.*
> *They will soar on wings like eagles;*
> *they will run and not grow weary,*
> *they will walk and not be faint. (Isaiah 40:28–31)*

Inside the frame to the right, letter the text from this passage in a script-style lettering. (Quick tip: When you're writing text, start in pencil first and draw some lines to write on. This will help keep your text straight and ensure you have enough room.) Next fill the frame with pictures related to the text. Pull different ideas from the vivid images that the text suggests and begin drawing. Maybe it will be eagles, or you could focus on the earth. Do your best to communicate what the words are saying by the pictures you sketch. Once you finish drawing, outline your work in ballpoint pen, erase your pencil lines, and color your frame in fully. This will make your artwork pop.

Let these words refresh you: "He gives strength to the weary." Sometimes our ability to receive encouragement or take time to rest lies in our frame of mind.

Try taking your images off the page to create variation.

CROSS-HATCHING

The cross carries so much symbolism. It was the instrument of death for our Savior, but it is a symbol of life for us. It reminds us of Jesus's sacrifice so that we can live forever. Aren't you grateful? Below are two verses about the cross. Spend a few moments reflecting on them.

> *[Let us fix] our eyes on Jesus, the pioneer and perfecter of faith. For the joy set before him he endured the cross, scorning its shame, and sat down at the right hand of the throne of God. (Hebrews 12:2)*
>
> *The message of the cross is foolishness to those who are perishing, but to us who are being saved it is the power of God. (1 Corinthians 1:18)*

Now you get to try your hand at cross-hatching. In art, cross-hatching is a series of lines crossing over one another to create shadows. The more lines that cross over each other, the darker the shadow becomes. (See tips on cross-hatching below.) On the page to the right is an empty cross for you to cross-hatch to create detail and to shade. Choose somewhere on the page to place your light source and add cross-hatching accordingly. Then pick one of the verses above to write creatively on the page to make it a scripturedoodle.

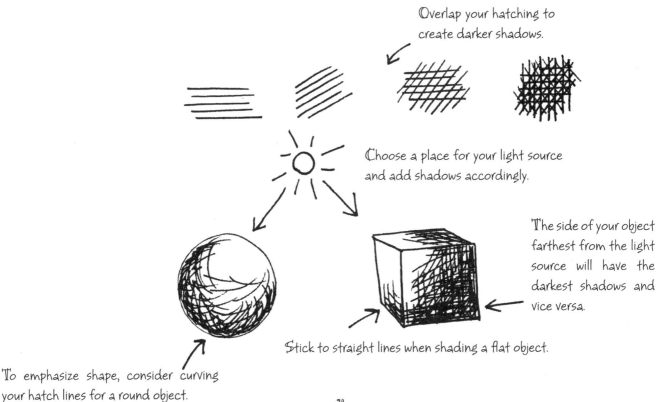

Overlap your hatching to create darker shadows.

Choose a place for your light source and add shadows accordingly.

The side of your object farthest from the light source will have the darkest shadows and vice versa.

Stick to straight lines when shading a flat object.

To emphasize shape, consider curving your hatch lines for a round object.

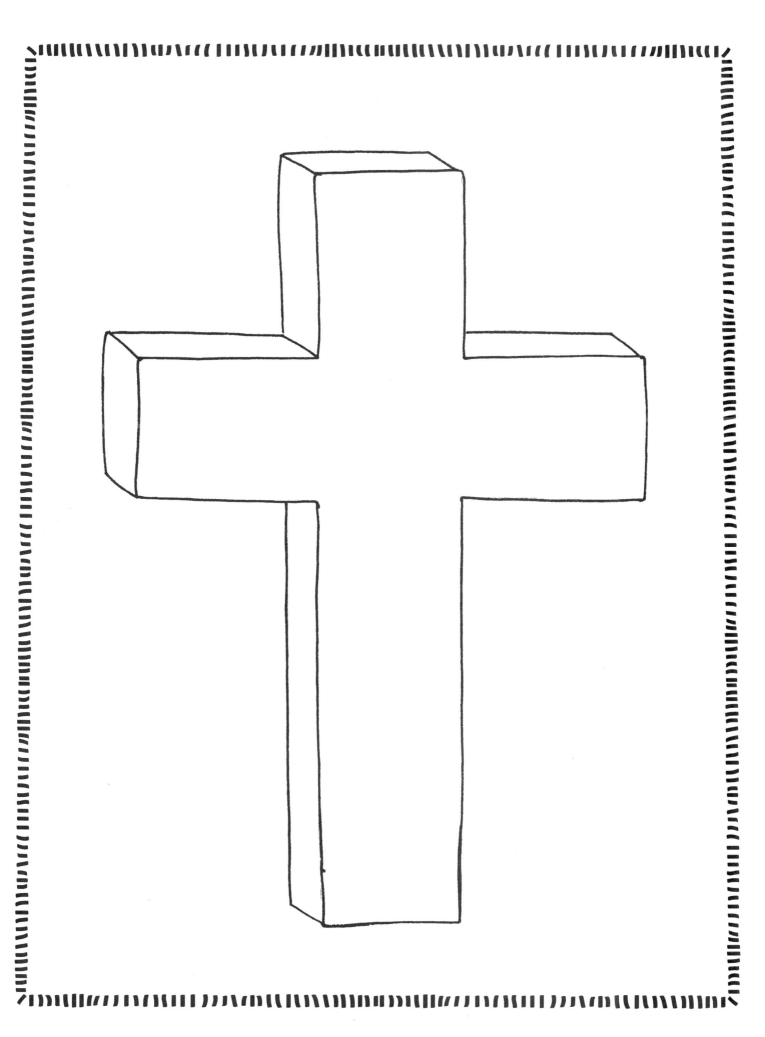

THE FIGHT

Doesn't it often feel as though this life is a fight? We hear the phrase "You've gotta fight for it," and the idea of fighting for ourselves or for our victory in a situation becomes something we wear like a medal of honor. But here's what the Word of God says:

The LORD will fight for you; you need only to be still. (Exodus 14:14)

Wherever you hear the sound of the trumpet, join us there. Our God will fight for us! (Nehemiah 4:20)

Do not be afraid of them; the LORD your God himself will fight for you. (Deuteronomy 3:22)

The LORD your God, who is going before you, will fight for you, as he did for you in Egypt, before your very eyes. (Deuteronomy 1:30)

In each of these passages, God's people were up against either an enemy, a nation, or something that seemed impossible, but God said, "The Lord will fight for you." It is not our job to fight; the battle is the Lord's. Our job is to be still, to be unafraid, and to trust him. May you rest in this truth today.

On the next page, make a scripturedoodle of one of the above verses. You may want to make it a word picture. Start by choosing a key word or two from the verse, and then emphasize words by making them large and giving them a special font. Finish off your word-style scripturedoodle with color.

IT IS WELL

You may know the story of the song "It Is Well with My Soul," which was penned in 1873 by Horatio Spafford. Shortly after experiencing complete financial ruin and finding out all four of his daughters drowned in a shipwreck, he wrote these words:

> When peace, like a river, attendeth my way,
> When sorrows like sea billows roll;
> Whatever my lot, Thou has taught me to say,
> It is well, it is well, with my soul.
>
> **Refrain:** It is well, with my soul,
> It is well, with my soul,
> It is well, it is well, with my soul.
>
> Though Satan should buffet, though trials should come,
> Let this blest assurance control,
> That Christ has regarded my helpless estate,
> And hath shed His own blood for my soul.
>
> My sin, oh, the bliss of this glorious thought!
> My sin, not in part but the whole,
> Is nailed to the cross, and I bear it no more,
> Praise the Lord, praise the Lord, O my soul!
>
> For me, be it Christ, be it Christ hence to live:
> If Jordan above me shall roll,
> No pang shall be mine, for in death as in life
> Thou wilt whisper Thy peace to my soul.
>
> But, Lord, 'tis for Thee, for Thy coming we wait,
> The sky, not the grave, is our goal;
> Oh trump of the angel! Oh voice of the Lord!
> Blessed hope, blessed rest of my soul!
>
> And Lord, haste the day when my faith shall be sight,
> The clouds be rolled back as a scroll;
> The trump shall resound, and the Lord shall descend,
> Even so, it is well with my soul.[1]

What images come to mind when you hear Spafford's story and read these words? Choose one line from the song that resonates with you and make a doodle of it, like a hymndoodle. Illustrate it on the page to the right. Keep in mind such things as color, lettering, and spacing as you complete your work.

1 Horatio Spafford, "It Is Well with My Soul," http://cyberhymnal.org/htm/i/t/i/itiswell.htm.

ARMOR OF GOD

Be strong in the Lord and in his mighty power. Put on the full armor of God, so that you can take your stand against the devil's schemes. (Ephesians 6:10–11)

Ephesians 6:10-17 lays out the armor of God for us. Take a few moments to read it. Isn't it interesting that this short passage says twice, "Put on the **full armor** of God"? We are not completely protected when we don only a portion of God's protection. We need his full armor. Which of the pieces of armor are easy for you to take on? Which do you find you struggle with the most?

Customize and complete the armor of God that's been started for you. Create one piece or as many as you wish. As you work on each one, take time to pray about the virtue it represents. Feel free to embellish the armor with anything you'd like. You might also decide to write the name of each piece somewhere on it. A few pieces are started below; you can complete them for practice and then move on to the next page.

BELT of TRUTH

BREASTPLATE of RIGHTEOUSNESS

FEET of PEACE

SHIELD of FAITH

HELMET of SALVATION

SWORD of the SPIRIT

BEAUTY IN COMMUNITY

Is community alive and well in your life? As humans, we were designed to live in community—to support each other and carry one another's burdens. This passage holds the most beautiful and inspiring description of true community:

> They devoted themselves to the apostles' teaching and to fellowship, to the breaking of bread and to prayer. Everyone was filled with awe at the many wonders and signs performed by the apostles. All the believers were together and had everything in common. They sold property and possessions to give to anyone who had need. Every day they continued to meet together in the temple courts. They broke bread in their homes and ate together with glad and sincere hearts, praising God and enjoying the favor of all the people. And the Lord added to their number daily those who were being saved. (Acts 2:42–47)

The last verse in this passage hits the home run as to why our community should look like this: it brings believers into the kingdom!

The purpose of this exercise is to represent the beauty in community. Start by choosing a shape or outline that you are comfortable drawing. The example below shows a butterfly. Then repeat the shape you chose continuously throughout the large circle. Feel free to make each shape a little different, just as each of us is different. Start in pencil, and once you finish, go over your lines with a fine-tip marker. As shapes overlap one another, color in the overlapped space with the same colored pencil, or use multiple colors to create variety. This represents sharing one another's needs and the support found in true community. After you finish, observe the beauty formed by many shapes coming together. Finish your work by adding a portion or all of verse 47.

Each time a line crosses another, color it in.

Keep the majority of your design inside the picture, but overlap parts of it for variety.

THROUGH THE PSALMS

The book of Psalms contains poems that express real feelings while also giving the hope of God. Have you ever read a psalm that was perfect for the season you were going through? Here's an encouraging passage from Psalm 103:

> Bless the LORD, O my soul,
>> and all that is within me,
>> bless his holy name!
> Bless the LORD, O my soul,
>> and forget not all his benefits,
> who forgives all your iniquity,
>> who heals all your diseases,
> who redeems your life from the pit,
>> who crowns you with steadfast love and mercy,
> who satisfies you with good
>> so that your youth is renewed like the eagle's. (Psalm 103:1–5 ESV)

Flip through the book of Psalms and choose a chapter that is especially meaningful to you. Then select one verse from the chapter to doodle. It doesn't have to summarize the whole chapter; it can be any verse that has an impact on you.

For review, here are the steps on how to scripturedoodle:

1. Choose a Bible verse—any Bible verse.

2. Pick one key word or phrase in the verse that brings a picture to mind.

3. Begin by drawing that image (or you can do text only).

4. Add elements around that image to fill out your page.

5. Write out the Bible verse somewhere on the page.

6. Create borders and other doodles.

7. Color it if you want.

UNEXPECTED CIRCUMSTANCES

Have you ever received news of unexpected circumstances that were not to your benefit? It is easy to trust and worship God when things are good, but when tragedy hits we often forget the many times God has been faithful in the past. The truth is, God will provide and he will continue to care for us in every circumstance, because faithfulness is his character! Here is a fraction of what the Bible says about God:

No one will be able to stand against you all the days of your life. As I was with Moses, so I will be with you; I will never leave you nor forsake you. (Joshua 1:5)

Know therefore that the LORD your God is God; he is the faithful God, keeping his covenant of love to a thousand generations of those who love him and keep his commandments. (Deuteronomy 7:9)

The LORD is good,
* a refuge in times of trouble.*
He cares for those who trust in him. (Nahum 1:7)

No temptation has overtaken you except what is common to mankind. And God is faithful; he will not let you be tempted beyond what you can bear. But when you are tempted, he will also provide a way out so that you can endure it. (1 Corinthians 10:13)

I call on the LORD in my distress,
* and he answers me. (Psalm 120:1)*

Take some time to make a word scripturedoodle of one of these verses that speaks to your heart. Choose a few of the words to emphasize with large text or color. Doodle all around it. Use the techniques you've practiced in previous exercises. You can also refer back to the coloring tips on pages 8–9 and the lettering tips on pages 12–13.

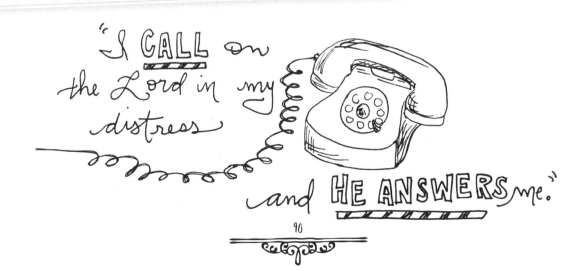

HE IS WORTHY

God is creator of all and the giver of all good things. Without him we are nothing, but the best news is that he chose you! And because of his grace and your acceptance of it, you will spend eternity with him. Take some time to praise God, because he is worthy!

> You are a chosen people, a royal priesthood, a holy nation, God's special possession, that you may declare the praises of him who called you out of darkness into his wonderful light. (1 Peter 2:9)

The Bible makes it evident that the Father desires our praise. Following are a few verses about that. Choose one for your next scripturedoodle, then pick a key word that brings a picture to mind and sketch it on the page to the right. A few key words from these verses are "praise," "nations," "call," "lamb," "power," and "wealth." You get the idea; all of these might bring a visual image to mind. As you doodle, take advantage of the use of color to express emotions. Then add the words around it in your own way.

> I will praise you, LORD, among the nations;
> I will sing the praises of your name. (2 Samuel 22:50)

> Praise be to the God and Father of our Lord Jesus Christ! In his great mercy he has given us new birth into a living hope through the resurrection of Jesus Christ from the dead. (1 Peter 1:3)

> In a loud voice they were saying:
> "Worthy is the Lamb, who was slain,
> to receive power and wealth and wisdom and strength
> and honor and glory and praise!" (Revelation 5:12)

> I called to the LORD, who is worthy of praise,
> and have been saved from my enemies. (2 Samuel 22:4)

> I will give thanks to you, LORD, with all my heart;
> I will tell of all your wonderful deeds.
> I will be glad and rejoice in you;
> I will sing the praises of your name, O Most High. (Psalm 9:1–2)

> I will sing the LORD's praise,
> for he has been good to me. (Psalm 13:6)

MADE NEW

This is the bottom line about Christ: he made us new through his death on the cross. The moment we chose to believe he rose from the dead to save us from our sins, we became his and he made us new. What a treasure we can rest in. There are plenty of verses that speak of this newness. Here's one from Romans:

> *We have been buried with Him through baptism into death, so that as Christ was raised from the dead through the glory of the Father, so we too might walk in newness of life. (Romans 6:4 NASB)*

 Think about the word **new**. So many things in our world are symbols of newness. Let's use the concept as a launching point for this exercise.

Thumbnail sketches are small drawings used to help artists develop multiple ideas quickly. And now you get to do a series of thumbnail sketches on anything that makes you think of the word **new**. Each drawing shouldn't take long; the idea is for it to be a quick sketch that sparks creativity. Start in pencil and then go over your lines in ink. After that, color your sketches with your medium of choice. Along the way, remind yourself of the new life that Christ brings, and the next time you see one of these things out in the world, you'll be reminded again.

≡YOU≡

MADE new

WITH WORDS

Written words may be the most commonly used expression of worship, but as you've seen through ScriptureDoodle, mixing art and words can enhance the experience. Let's combine these two things in a new way.

First, pick a Bible verse or two to work from. Look for ones that offer something visual, such as Noah's ark, the fruit of the Spirit, or the body of Christ. Or just pick any verse you love!

Once you settle on a passage, think of something you could draw related to the theme that is recognizable by only the outline. Hebrews 13:1-2 features hospitality. In the South, a pineapple is a symbol of hospitality, and it is a great choice for this exercise because a pineapple can be easily identified by its outline.

For your verse, pick an image with a strong shape and begin the outline of your object in pencil. Then add the verse inside it. The idea is to fill the whole space inside the shape with words so that if you erase the outline, you can still tell what the shape is (although you don't have to erase it). As you create, start first in pencil and then come back and outline your shape and verse with a ballpoint pen. Finish your scripturedoodle with color.

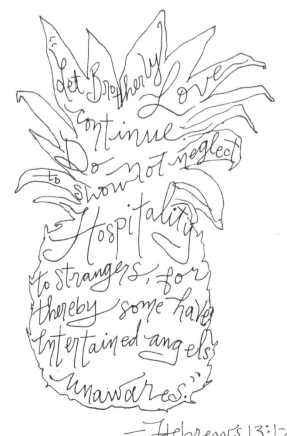

Let Brotherly Love continue. Do not neglect to show not Hospitality to strangers, for thereby some have entertained angels unawares.

Hebrews 13:1-2

BY FAITH

Faith is confidence in what we hope for and assurance about what we do not see. (Hebrews 11:1)

Faith equals confidence. How often are we confident in the things of this world that could easily fail us? Like when you sit in a chair a hundred times without ever considering that it could break and dump you on the floor. A chair is an earthly thing and could easily fail us. But God? He will **never** fail us. He is always faithful, as his Word tells us.

> *Because of the LORD's great love we are not consumed,*
> *for his compassions never fail.*
> *They are new every morning;*
> *great is your faithfulness. (Lamentations 3:22–23)*

Take a few minutes to read the rest of Hebrews 11. It holds an awesome account of people who put their faith in God even before he answered their prayers.

After reading, ask yourself this question: How could my life change if I increased my faith in God? God counted the people in Hebrews 11 as righteous for their belief in him. He'd count you as righteous too.

Think about the passage you've just read and choose one of the stories mentioned by the writer of Hebrews. Then create a story-type of scripturedoodle displaying the faith of the person who believed God. As you plan your picture, think of one key element in the story that is visual and start your drawing that way. Maybe it's Noah's ark, or perhaps it's the walls of Jericho falling down. Draw the element as best you can, and remember it doesn't have to be perfect. Then add in a portion of the verse you chose. And as you create, pray that God would increase your faith in him for the things unseen and his promises not yet received.

By Faith

STAINED GLASS

Better is one day in your courts
than a thousand elsewhere;
I would rather be a doorkeeper in the house of my God
than dwell in the tents of the wicked. (Psalm 84:10)

♡ ♡ ♡ ♡ ♡ ♡ ♡ ♡ ♡ ♡ ♡ ♡ ♡ ♡ ♡ ♡ ♡

The house of God is truly a beautiful place, and his presence is its loveliest feature. Stained glass windows are another beautiful feature of many churches. They are detailed masterpieces that take precision and skill to create. Some are unadorned, while others are elaborate and may display a detailed account of the story of Jesus, kind of like a scripturedoodle in the 1800s.

♡ ♡ ♡ ♡ ♡ ♡ ♡ ♡ ♡ ♡ ♡ ♡ ♡ ♡ ♡ ♡ ♡

Create a scripturedoodle in the stained glass window on the page to the right. You can make it by showcasing shapes and color, or you can spend time crafting a detailed illustration of something from Scripture. Incorporate the verse from above or choose one of your own.

GOD SEES

May these words encourage you the next time you take the high road and nobody sees. For the moment when you hold your tongue but everything inside you is screaming, God sees. For the time you forgive someone who has utterly wronged you, God sees. He sees it all. The daily battles you fight and the ways you choose to honor him, he sees, and he is so pleased with you. We live for the approval of God, not man, and the choices we make to take the high road are not always rewarded here on earth. But they will be rewarded in glory.

> Your ways are in full view of the LORD,
> and he examines all your paths. (Proverbs 5:21)
>
> Whatever you do, work at it with all your heart, as working for the Lord, not for human masters, since you know that you will receive an inheritance from the Lord as a reward. It is the Lord Christ you are serving. (Colossians 3:23–24)

God promises the reward of inheritance for those of us who choose to live and work unto him. As hard as this is sometimes, we can't go wrong choosing to be selfless and to honor God, for that was Jesus's example to us when he went to the cross.

Choose one of the verses above. What images come to mind? On the page to the right, you may want to draw yourself taking the high road, either literally or in a metaphorical sense through an act that honors God. Perhaps you can recount an instance when you showed undue kindness or forgiveness; illustrate it on the next page. You might instead choose to create an abstract expression of the high road either by shapes or color.

SPEAK LIFE

Words are powerful. They can heal our hearts or crush our spirits. God's Word is full of encouragement in this area:

A person finds joy in giving an apt reply—
and how good is a timely word! (Proverbs 15:23)

The tongue has the power of life and death,
and those who love it will eat its fruit. (Proverbs 18:21)

Instead, we will speak the truth in love, growing in every way more and more like Christ, who is the head of his body, the church. (Ephesians 4:15 NLT)

This exercise is about the art of speaking life. You could think of it as a vault of life-giving words you'll have stored up, ready to give out when needed. What are some thoughtful words you can give to anyone? Write them creatively in the vault on the page to the right. This is a great space to practice your creative lettering skills, block letters, script letters, or any letters you wish. As always, make it your own by adding color and details.

Here are a few encouraging statements to help you get started:

What a beautiful smile!

I can tell you're working hard today.

You have a lovely family.

I hope you have a great day.

Jesus loves you.

I love you.

DREAM CHASERS

"I know the plans I have for you," declares the LORD, "plans to prosper you and not to harm you, plans to give you hope and a future."
(Jeremiah 29:11)

God can do anything with a willing and obedient heart. Think about David, who had incredible faith and was willing to be obedient to God even in circumstances that looked crazy to the world (see, for instance, 1 Samuel 17).

The plans are God's; the work is his. The obedience—that's our job. Has God put a dream in your heart? If so, would you consider saying yes to him? Some people live their whole lives wondering what it would've been like if they'd been brave enough to follow their dreams.

If you could do anything in the world, what would it be? Take some time to pray about it. Then make a scripturedoodle of Jeremiah 29:11. Integrate into your picture the dream God has stirred in your heart so you can walk in obedience to all that he has for you. He will show you the way. After all, the dream in your heart was his first.

The example to the right represents the dream of ScriptureDoodle.

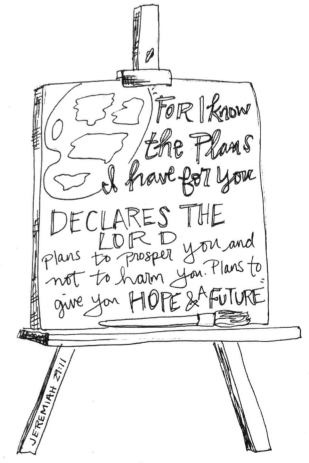

ALIVE AND ACTIVE

The word of God is alive and active. Sharper than any double-edged sword, it penetrates even to dividing soul and spirit, joints and marrow; it judges the thoughts and attitudes of the heart. (Hebrews 4:12)

What vivid images this verse brings to mind! Think of oppressed places of the world where having an open Bible could get you killed. What a privilege we have to freely study and share God's Word with others. This is not something we should take for granted.

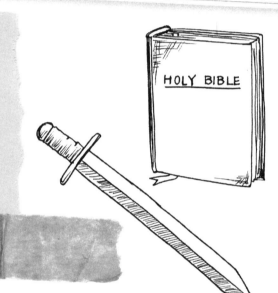

Create a scripturedoodle of this verse and include these things:

1. Something that represents the Word of God. The easiest way may be to draw a Bible, but that is up to you.

2. A sword. Think of a creative way for a sword and Bible to work together in your picture. Also, keep in mind the things you've learned about drawing and shading.

3. The text of Hebrews 4:12. Add it anywhere you choose in the picture.

Feel free to doodle more images.

WE ALL HAVE A MINISTRY

And God has placed in the church first of all apostles, second prophets, third teachers, then miracles, then gifts of healing, of helping, of guidance.
(1 Corinthians 12:28)

Even if you're not working in full-time ministry, God has given you a place in this world to draw others to his heart. We must understand the hope of Jesus and be passionate about bringing it to others. Wherever you serve God, your service is valuable and has the power to affect hearts forever. It is a privilege to carry the gospel. Take some time to examine your place in life as a ministry. Do you find value in what you are doing? If not, ask the Lord to pour into you fresh vision.

The empty church on the next page is meant to symbolize ministry in general. What images come to mind when you think of your own "ministry"? Sketch them in the space provided. Then add the verse above or write a prayer specifically for your ministry. Ask God to reveal his dreams for your ministry and let this moment be a turning point in your ministry for the kingdom.

FIND JESUS

> Let the sea resound, and everything in it,
> the world, and all who live in it.
> Let the rivers clap their hands,
> let the mountains sing together for joy;
> let them sing before the LORD,
> for he comes to judge the earth.
> He will judge the world in righteousness
> and the peoples with equity. (Psalm 98:7–9)

Isn't it amazing that God made this whole world? Let's take some time to sing his praises, because he is worthy!

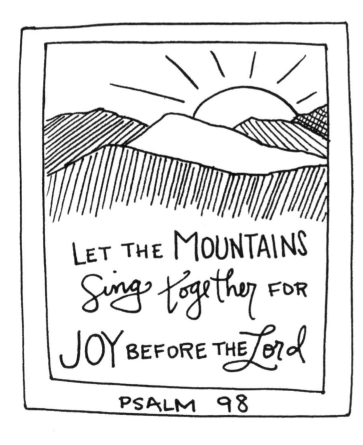

LET THE MOUNTAINS sing together FOR JOY BEFORE THE Lord

PSALM 98

Do you feel God in nature? Perhaps at the beach or the mountains? The purpose of this exercise is to create a piece of worship art for God. You might even add a verse of praise to it. On the page to the right, do your best to capture the place where you feel God the most. You can work from a photo or create from your memory. What's most important is that you spend this time appreciating God for his beautiful creation.

Here are a few praise-focused verses: 2 Samuel 22:4; Psalm 63:3–5; 71:8, 14; 107:8.

PURSUE HIM

My soul follows close behind You;
Your right hand upholds me. (Psalm 63:8 NKJV)

As you near the end of this book, be encouraged. You've basically created your own visual devotional! May you remember this time with God and continue to take it deeper. A life after him is the **best** life!

Here are a few statements about God, ministry, and this life of following Jesus. Let them encourage you and keep you motivated in your quest for God and in your place of creative expression with him.

We do not have to apologize for the gospel; it is right and true.

The gospel is ours only because it has been given to us.

Our God will fight for us.

Thank you, God.

God cares more about a willing heart than the skills we possess.

God is our provider.

This is God's story; we are blessed to be part of it.

Make a word doodle of one of these statements that rings true in your heart. You can also color the example to the right.

HEAVEN AND EARTH

> "My thoughts are not your thoughts,
> neither are your ways my ways,"
> declares the LORD.
> "As the heavens are higher than the earth,
> so are my ways higher than your ways
> and my thoughts than your thoughts." (Isaiah 55:8–9)

Have you ever wondered **how** honest you can be with God? Perhaps you doubt he really fed all five thousand people. Or what if you ask the wrong question? The truth is, God's not afraid of you. He is God, he made you, and he cherishes your heart. Even though his thoughts are higher than your thoughts, he still cares to hear yours. There's nothing you could ask him that would change his love for you. We won't always understand God and his ways because his ways are high above ours.

Incorporate the verses from Isaiah into the picture on the page to the right. Letter the text in a creative way in the space of the heavens above the earth. Imagine what the heavens look like and draw them in the top portion of the page with the Bible verses. As you create, spend a few moments talking to God about questions you have.

WHO WILL YOU TELL?

Jesus's last words to us before he died on the cross were "It is finished." Now we can trade our sorrow for joy because he paid the most perfect price to give us life forever. What an incredible gift.

> *The wages of sin is death, but the free gift of God is eternal life through Christ Jesus our Lord. (Romans 6:23 NLT)*

Have you accepted this free gift of life forever? If so, who will you tell? Sharing the good news of Jesus is the best gift we could share with anyone. Do you have a close friend or family member who doesn't know him? Sometimes sharing the gospel feels scary, but the work of salvation is God's job. Our job is to share the story.

If you're not sure of your salvation, take a moment to pray and tell God you believe he is who he said he is—that he sent his son to die so you can be forgiven of sin and live for eternity in heaven with him. Welcome to the family of God!

On this last page, make a scripturedoodle of Romans 6:23. By this point, you know all about how to make one from scratch. But just in case, here's one more refresher on how to scripturedoodle (on any size paper or card):

1. Choose a Bible verse—any Bible verse.

2. Pick one key word or phrase in the verse that brings a picture to mind.

3. Begin by drawing that image (or you can do text only).

4. Add elements around that image to fill out your page.

5. Write out the Bible verse somewhere on the page.

6. Create borders and other doodles.

7. Color it if you want.

After you finish, ask God to lay on your heart the name of someone to share this scripturedoodle with. Perhaps it will open a conversation that will lead to the person's salvation. And now that you're a pro at scripturedoodling, please teach someone else how to do it. Be sure to share on social media using #scripturedoodle and tag @scripturedoodle.

ABOUT THE AUTHOR

April Knight is an artist and a worshipper who loves all colors and can't seem to pick a favorite. She likes tea more than coffee, and she loves stories of God's faithfulness. She began painting and making art as a teenager but felt a strong call to pursue art ministry in her early twenties. Today, April paints for church services, events, and conferences. She also provides online, local, and international ScriptureDoodle workshops.

April and her husband, Robert, live in North Carolina and are the parents of a wild and handsome boy, Jedidiah, and a sweet girl named Penelope. April likes spending time with family and friends, and aspires to be organized. However, she says, "God has called me first to use my gifts as an artist to worship him and make his name known, and then to encourage others to do the same. I have huge dreams for ScriptureDoodle, and most of all, I want my heart to be an instrument of God in the way of creative ministry. Let's make Jesus famous together!"

Visit April Knight online through these links:

Website: http://worship-artist.com
Facebook: www.facebook.com/worshipartistministries
Twitter and Instagram: @Worship_Artist and @scripturedoodle